SENSATIONAL SUCCULENTS

SENSATIONAL
SUCCULENTS

An adult coloring book of
amazing shapes and magical patterns

From the Queen of Succulents
DEBRA LEE BALDWIN
with illustrations by
LAURA SERRA

TIMBER PRESS ⫽ PORTLAND, OREGON

SUCCULENTS, like seashells and snowflakes, embody nature's exquisite patterns and geometry. To provide the images for this book, I sorted through hundreds of photos, selecting those that present succulents at their most beautiful. Berlin-based artist and illustrator Laura Serra transformed my images into the inspiring drawings on these pages. Now it's your turn! Take these gorgeous plants to the next level by creating artworks that perfectly express your taste and style. Happily, succulents come in all colors—including sky blue, lavender, teal, orange, and chartreuse—so feel free to use a variety of hues and to create dramatic combinations. As you bring these drawings to life, you'll participate in a transcendent process: making already lovely plants even more so. It's an honor to provide inspiration for your artistry! Do share your results and view those of others at https://www.pinterest.com/debraleebaldwin/ succulent-coloring-book-art/.

—DEBRA LEE BALDWIN

Aeoniums

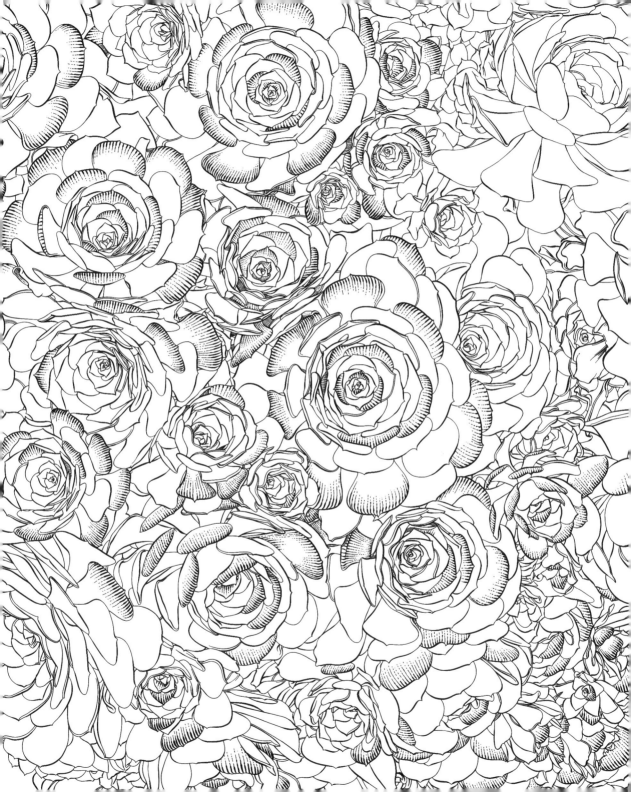

Agave 'Blue Flame' and *Agave* 'Blue Glow'

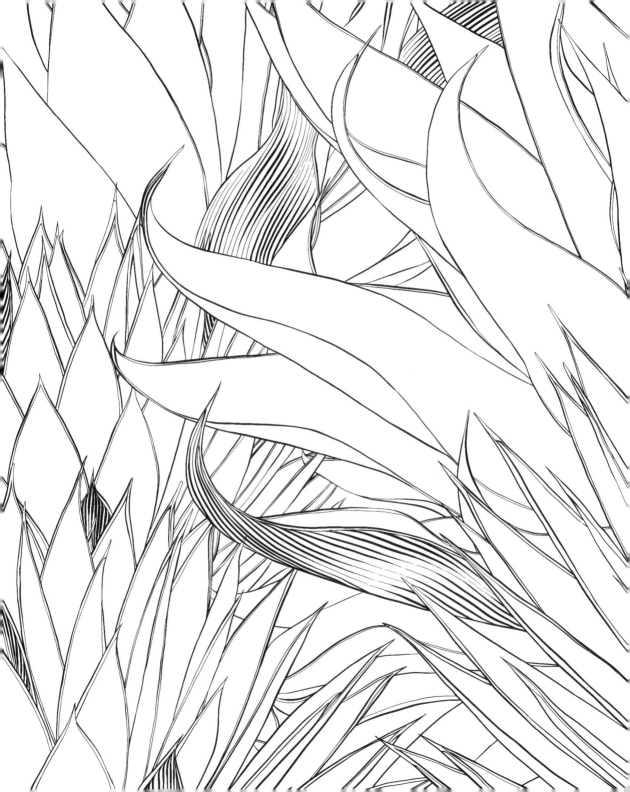

Agave pelona

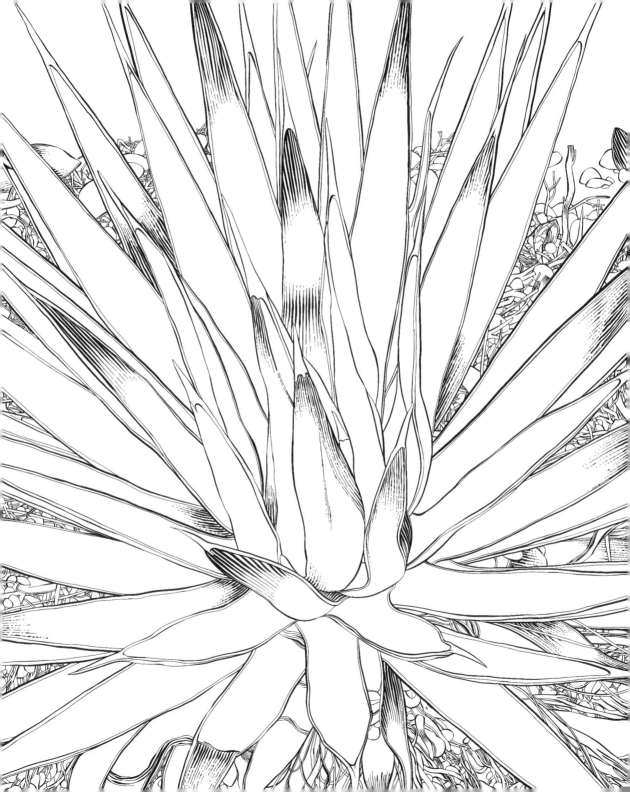

Aloes, coppertone stonecrop, and burro tail (*Sedum burrito*)

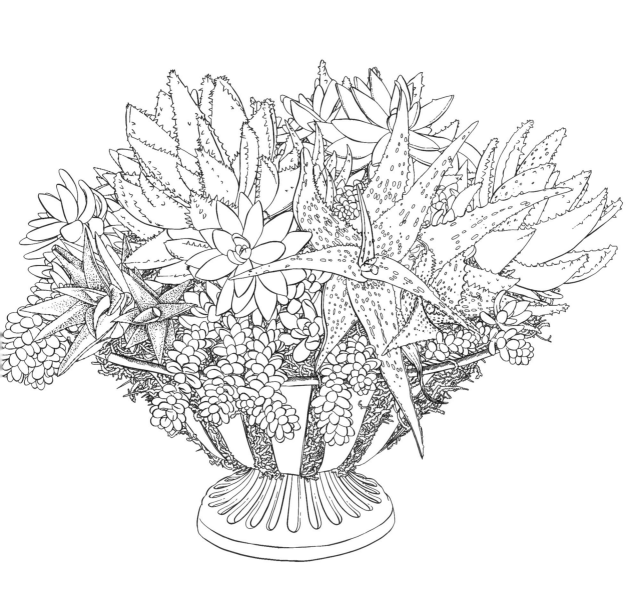

Kalanchoe tomentosa 'Chocolate Soldier', *Kalanchoe orgyalis*, and *Sedum* 'Dragon's Blood'

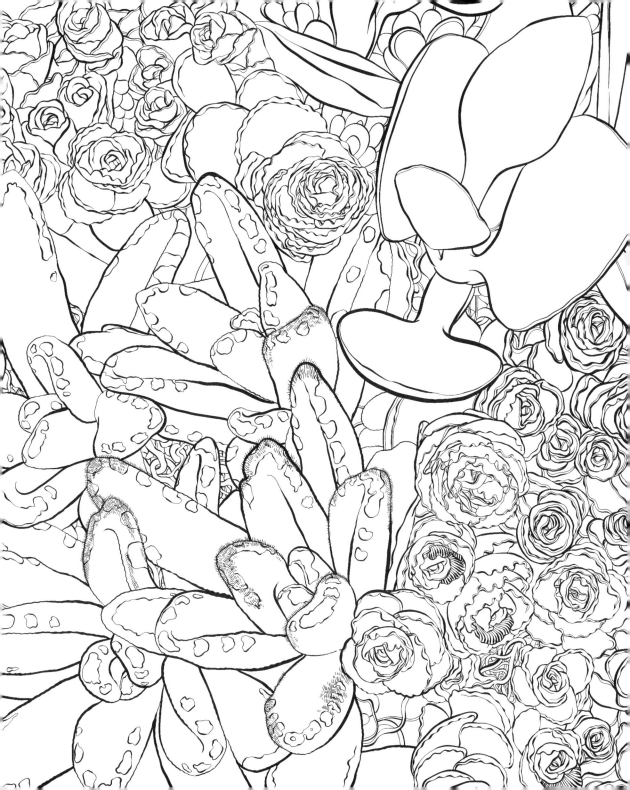

Mandala of echeverias and sempervivums in bloom, plus sedums, graptosedums, and graptopetalums

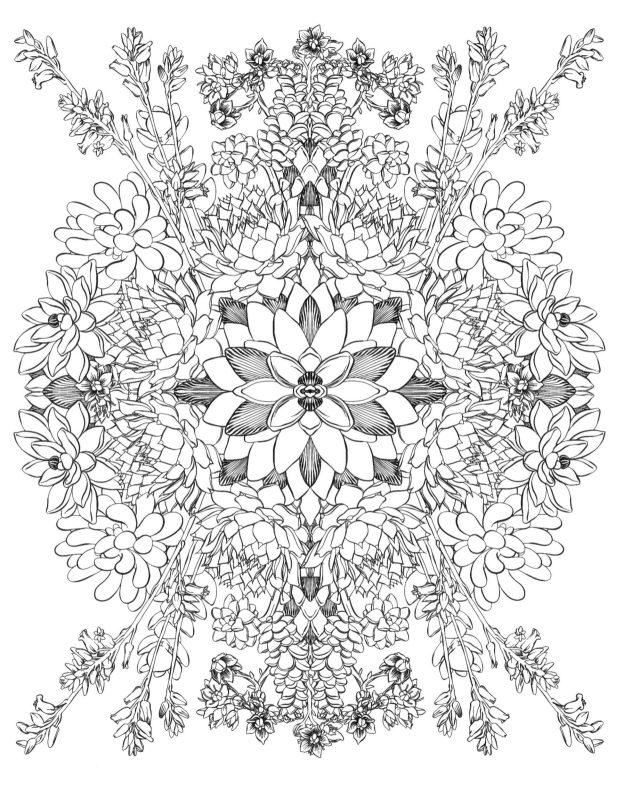

Aloe vanbalenii

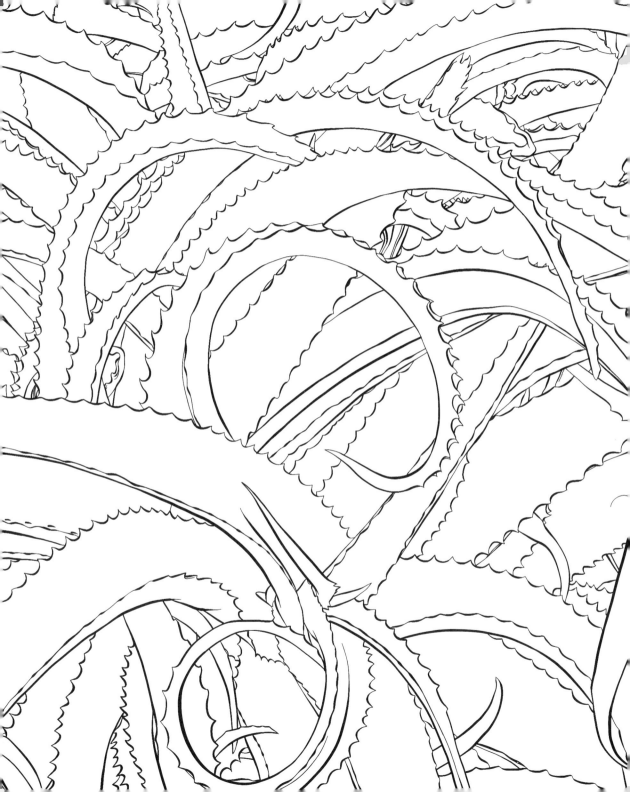

Aloe nobilis

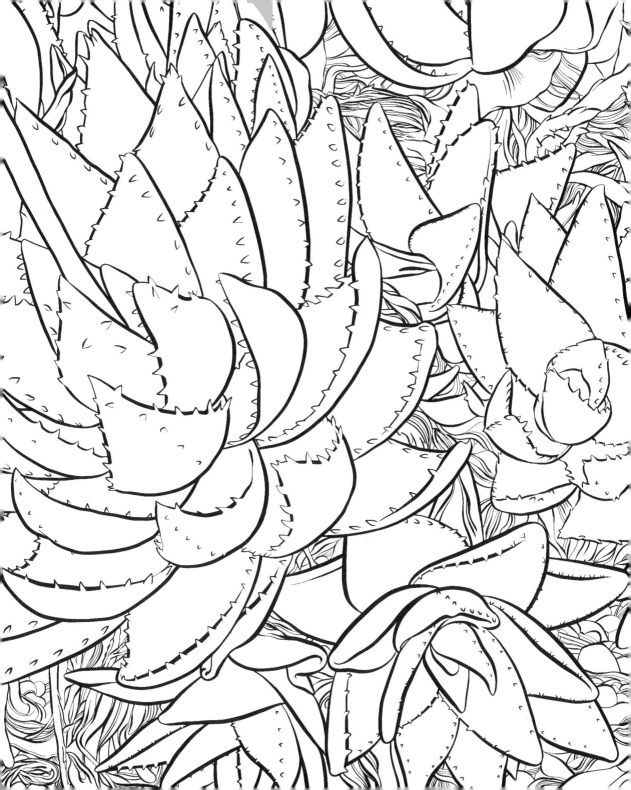

Orostachys malacophylla var. *iwarenge*

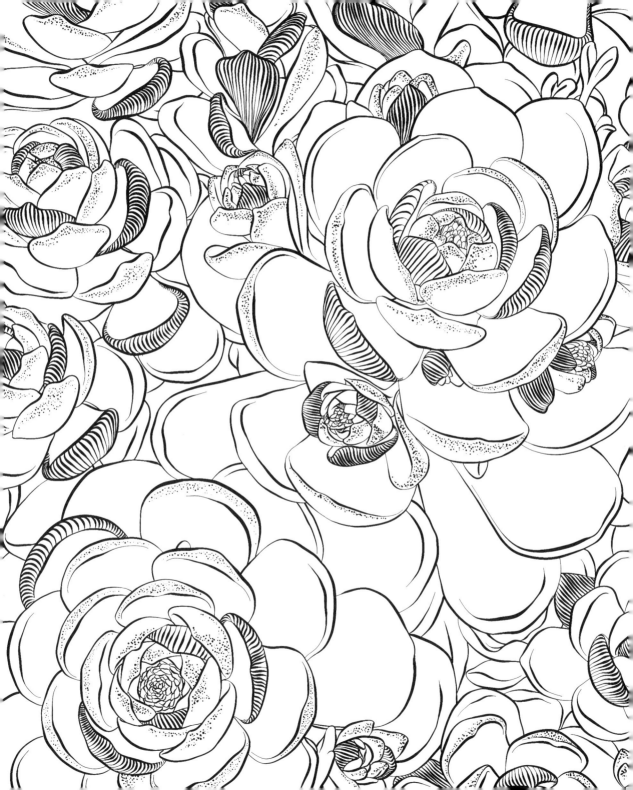

Mandala of echeverias, pachyverias, graptopetalums, and sedums

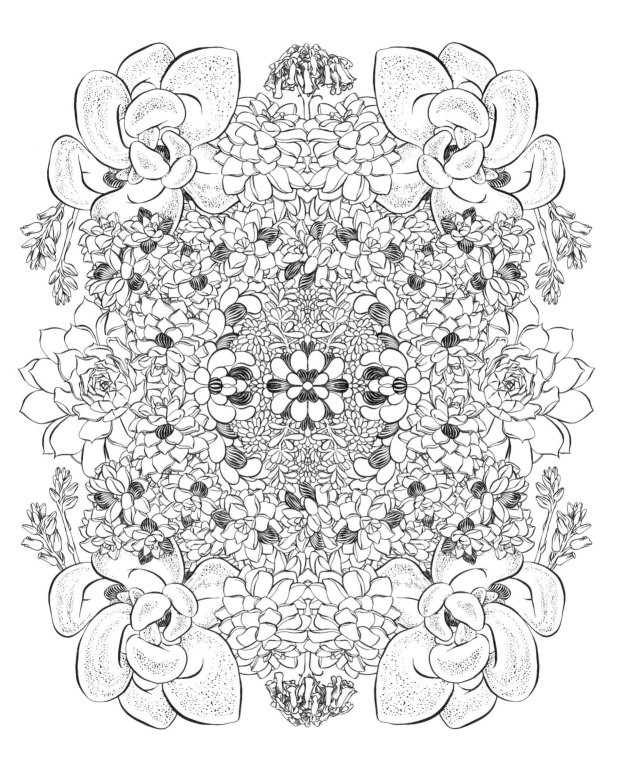

Euphorbia gorgonis

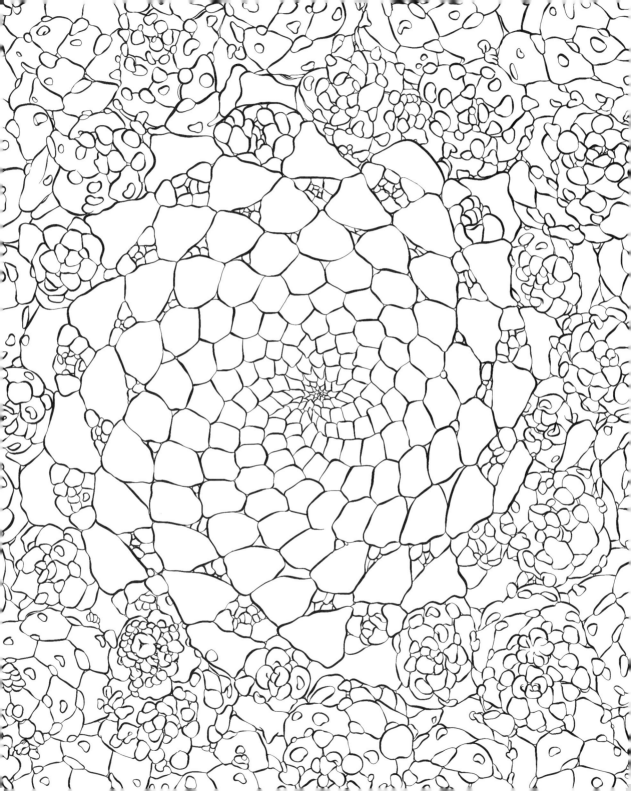

'Campfire' crassula, echeverias, aeoniums, sempervivums, haworthias, and sedums

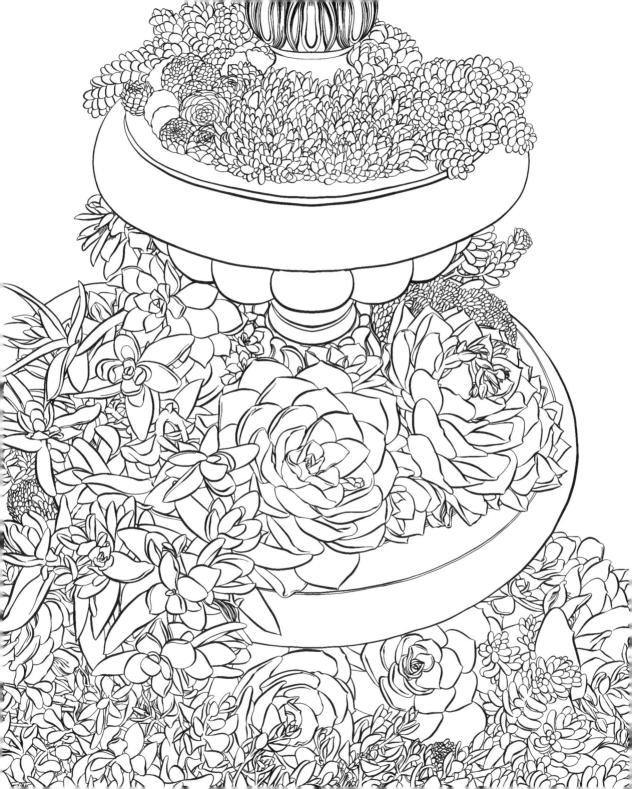

Aeoniums and sempervivums with jade (*Crassula ovata*), *Sedum* 'Tricolor', and graptosedums

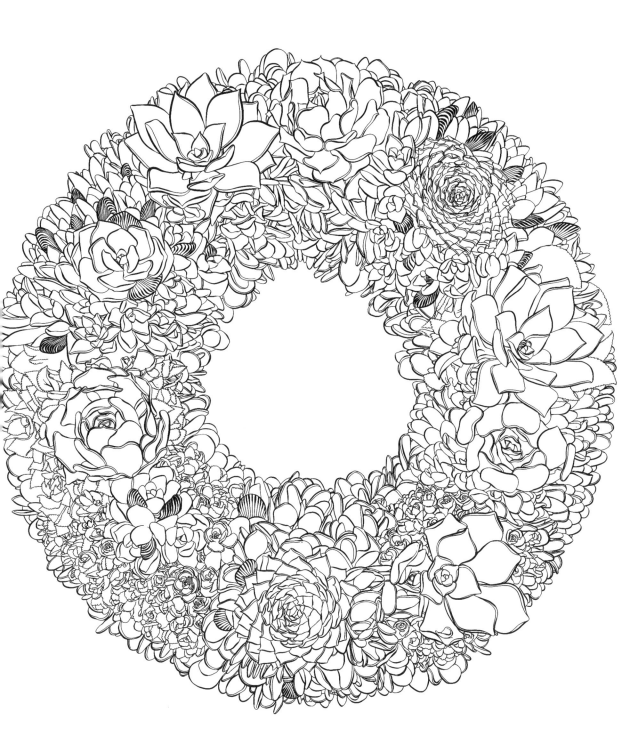

Pachyveria species

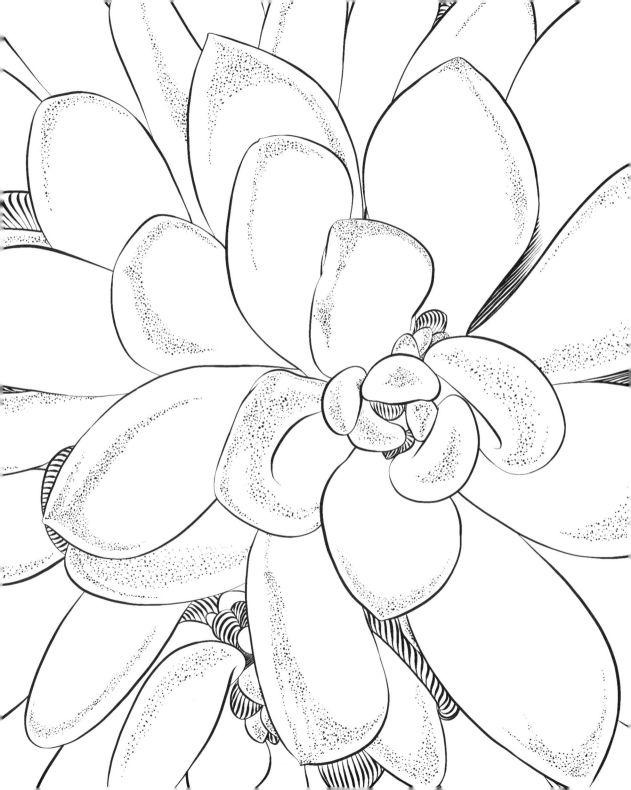

Mandala of echeverias and fenestraria

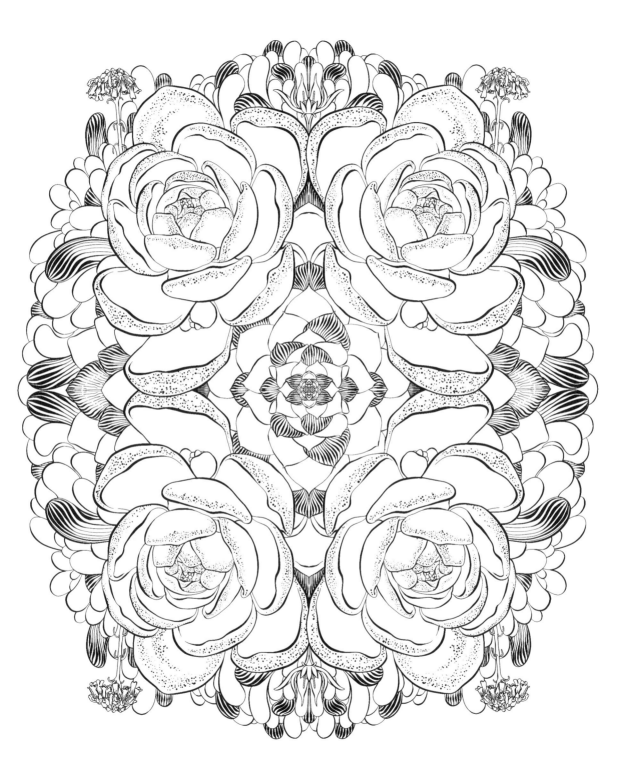

Euphorbia 'Snowflake'

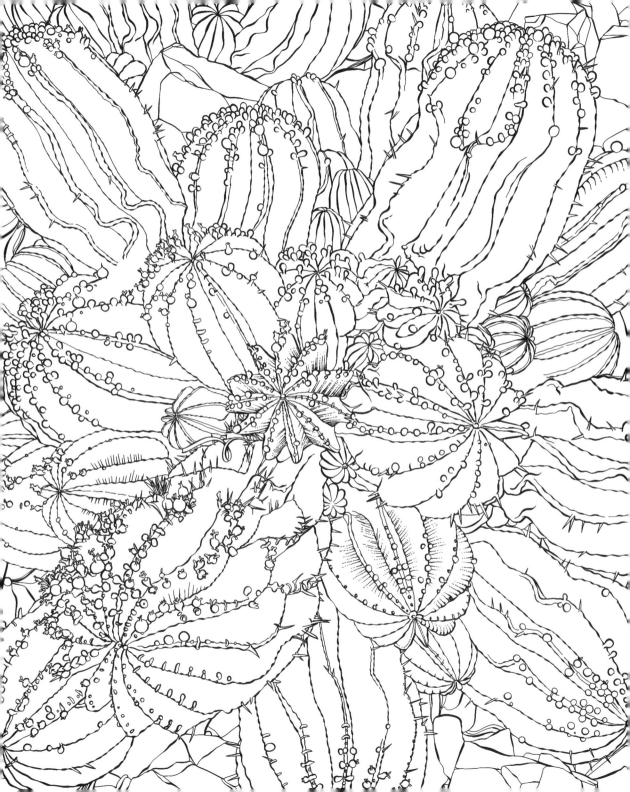

Aeonium 'Kiwi'

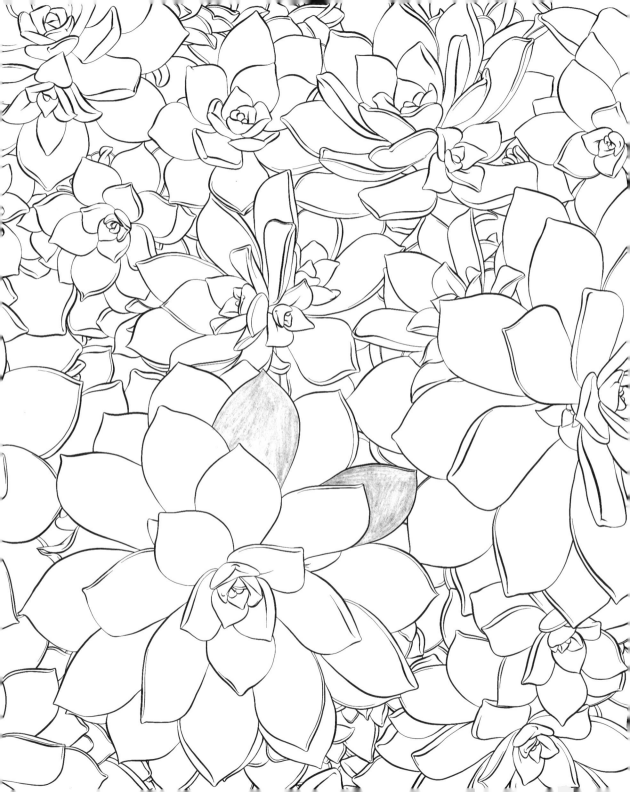

Crassulas and aeoniums

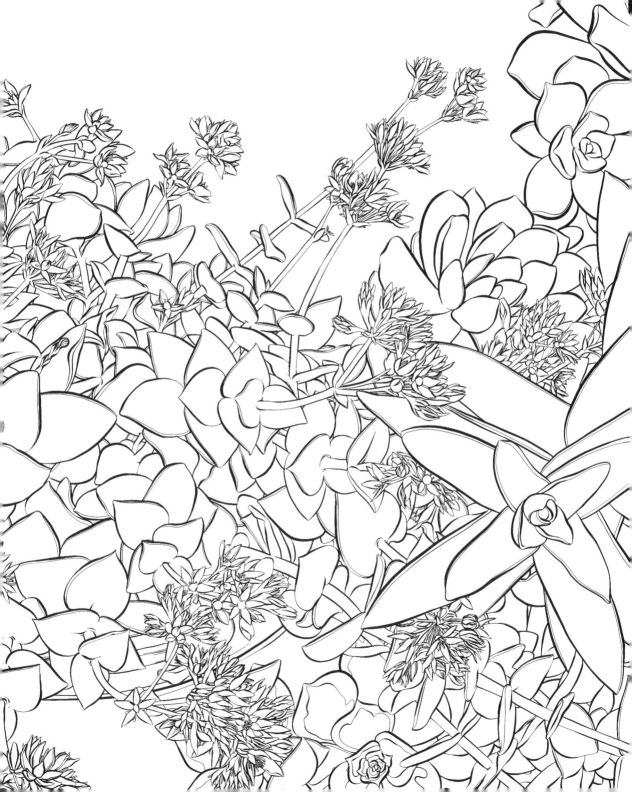

Cremnosedum 'Little Gem'

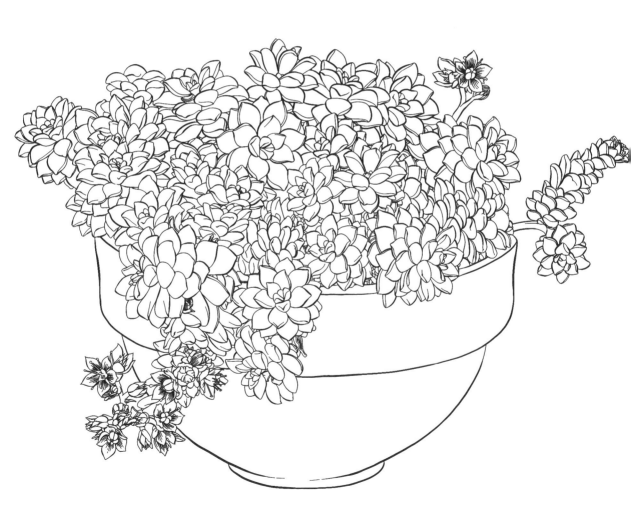

Ruffled echeveria cultivar

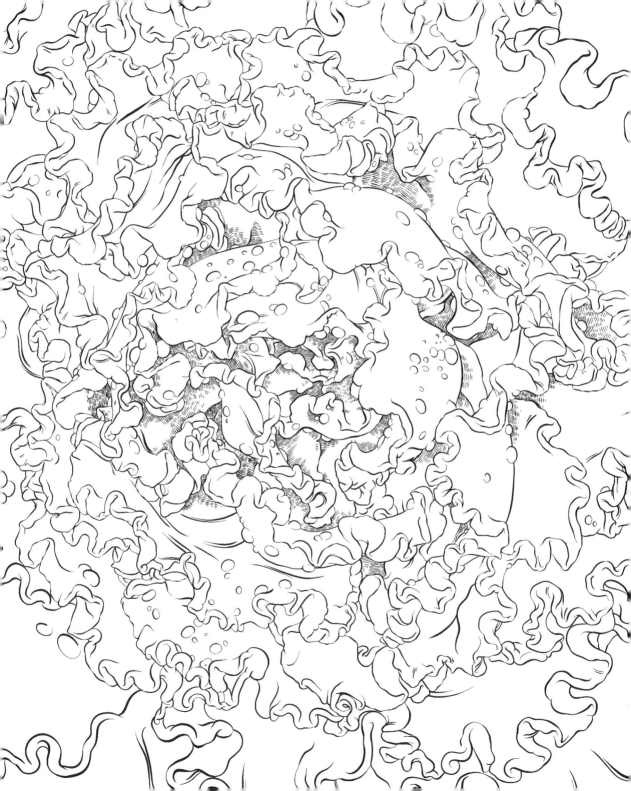

Graptoveria 'Opalina'

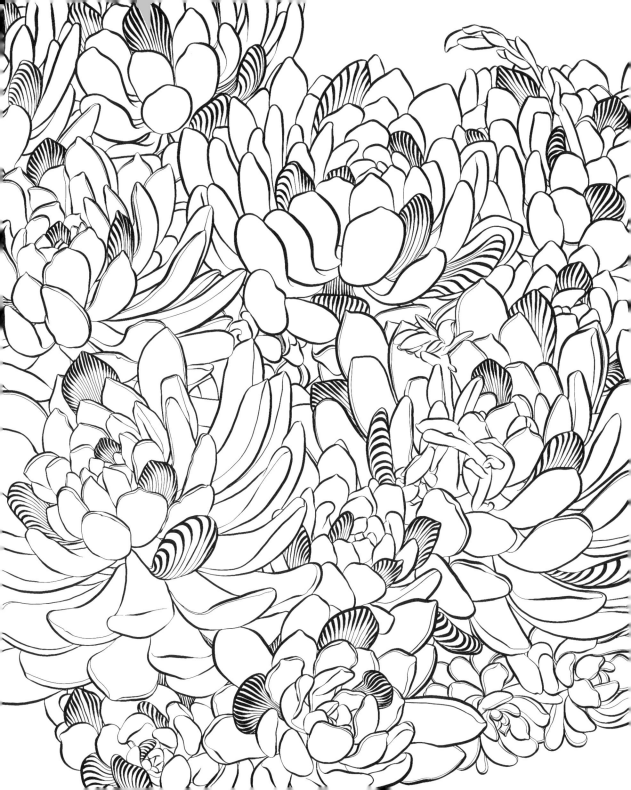

Aeoniums, graptoverias, sedums, echeverias, haworthias, crassulas, and kalanchoes

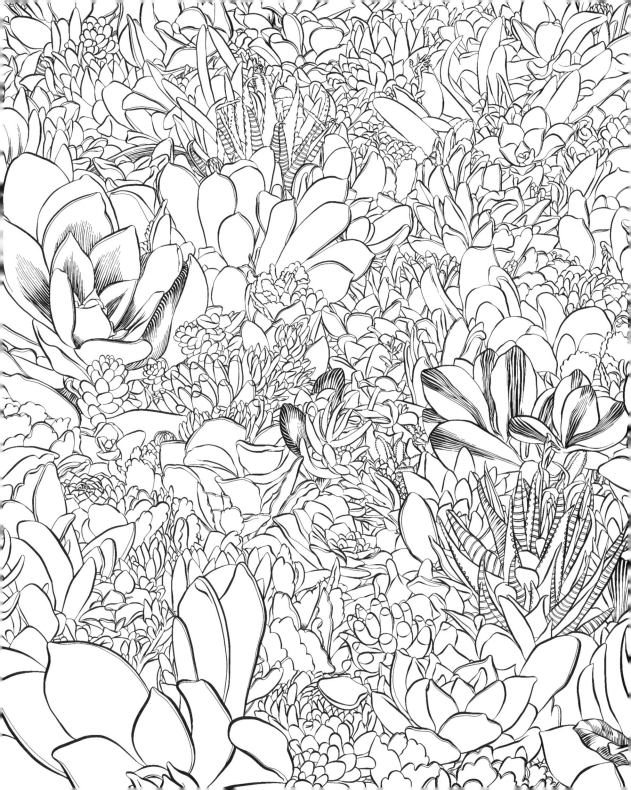

Echeveria hybrid

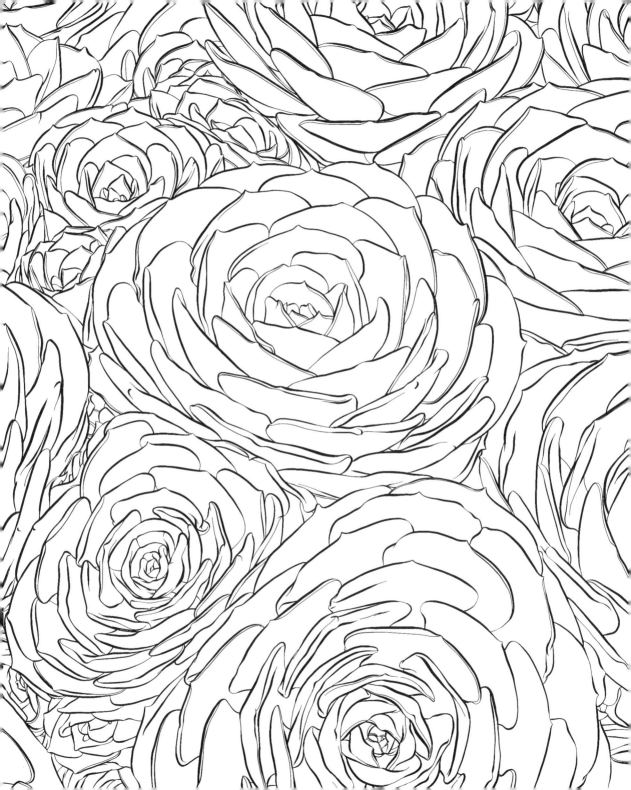

Agave attenuata (in pot), *Kalanchoe tubiflora*, ceroid (columnar) cacti, *Graptoveria* 'Fred Ives', and *Agave* 'Blue Glow'

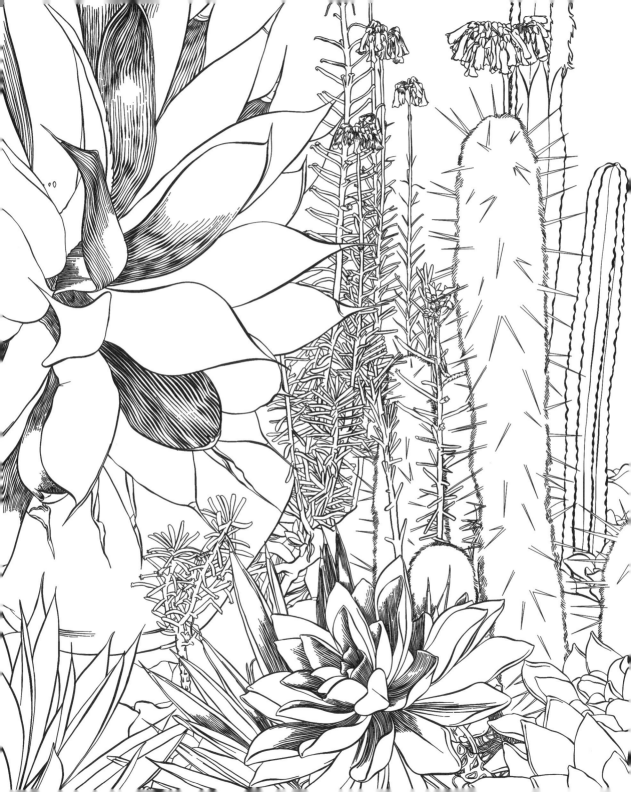

Sedum rubrotinctum 'Pork and Beans'

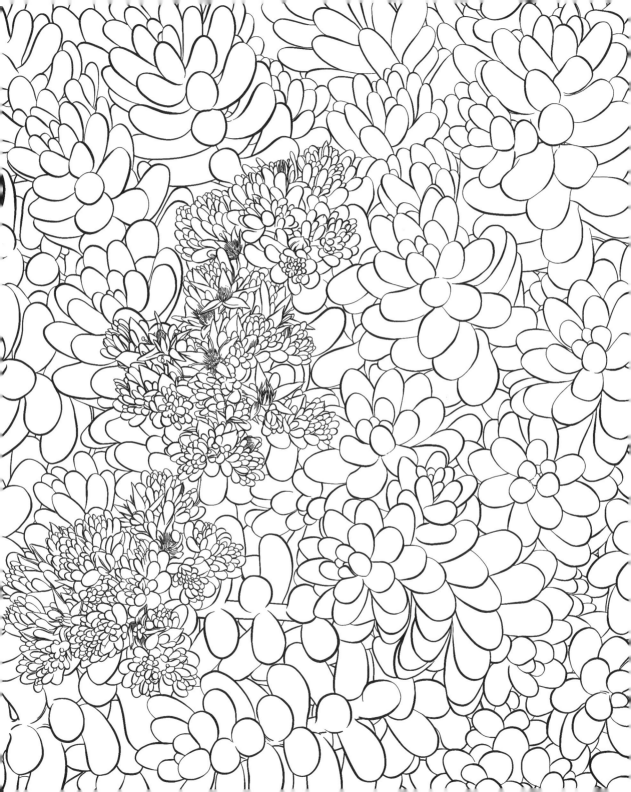

Echeverias, sedums, sempervivums, and pachyphytums

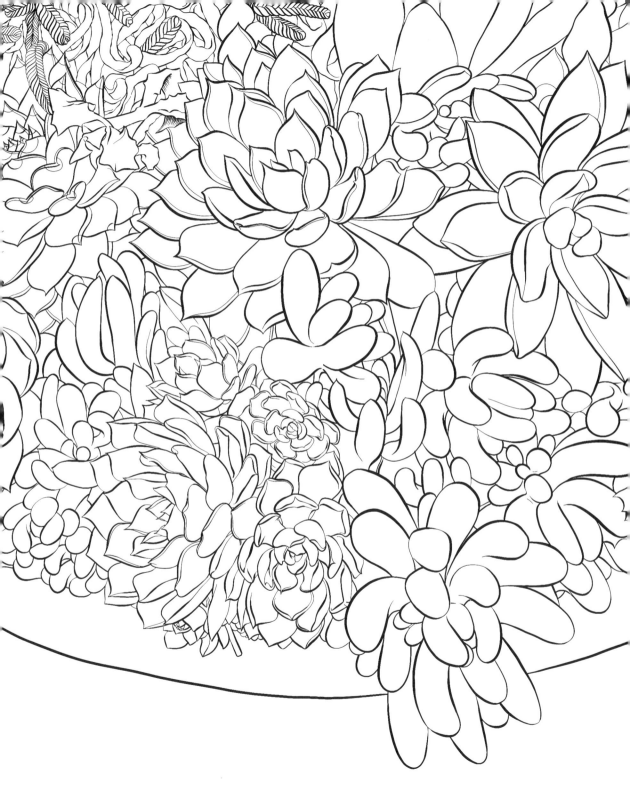

Ruffled echeveria cultivars

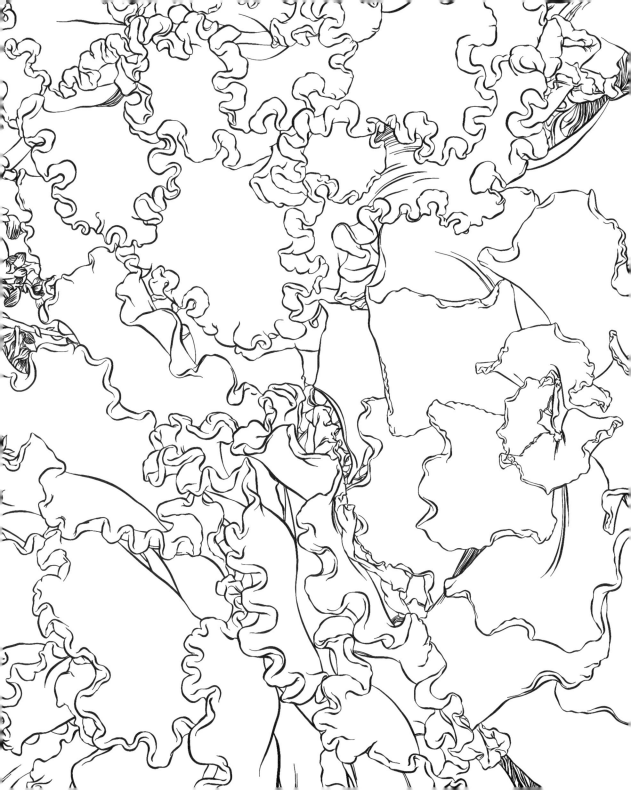

Graptoveria 'Fred Ives'

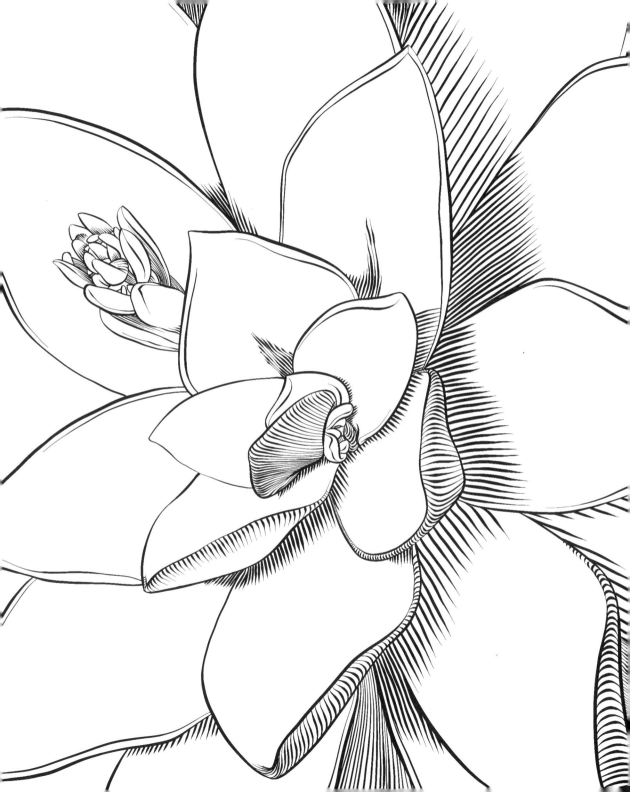

Echeverias, crassulas, sempervivums, aeoniums, *Euphorbia tirucalli* 'Sticks on Fire', *Kalanchoe tomentosa*, and sedums

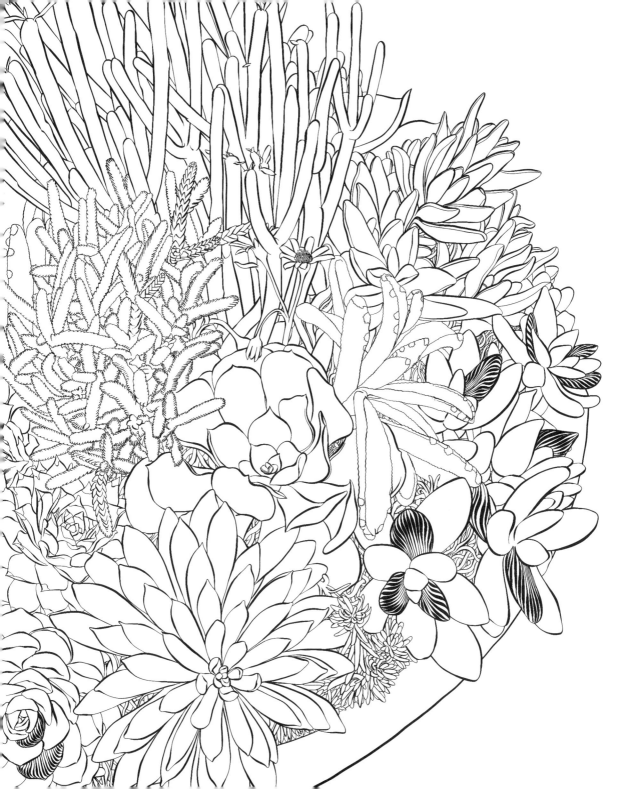

Crested aeoniums

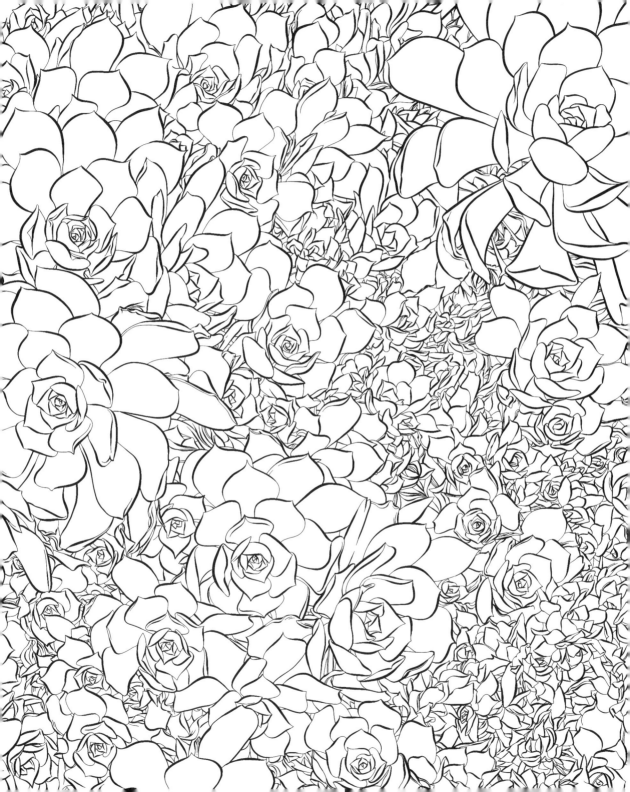

Agave parryi 'Truncata', *Mangave* 'Blood Spot', *Agave* 'Blue Glow', *Agave victoriae-reginae*, *Agave* 'Cream Spike', *Echeveria* 'Afterglow', and *Crassula* 'Campfire'

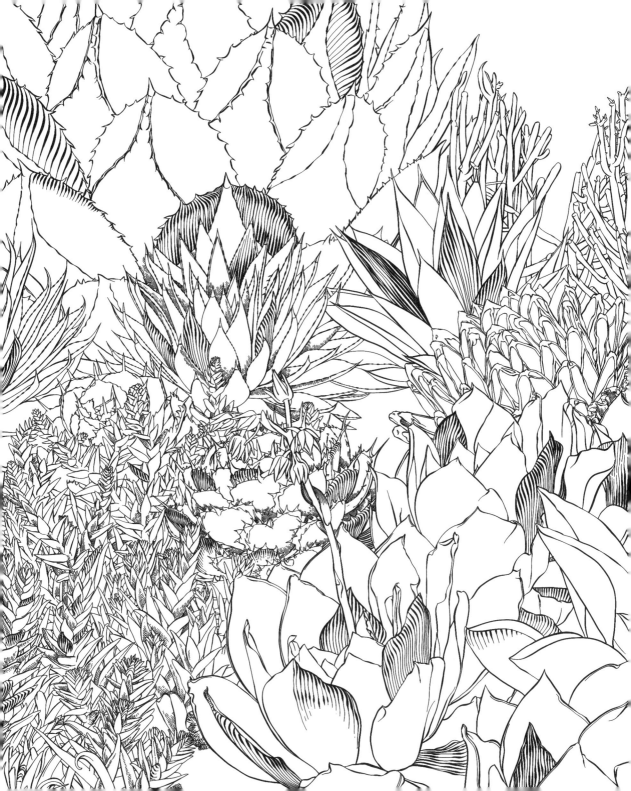

Sempervivums, *Cremnosedum* 'Little Gem', and *Crassula* 'Campfire'

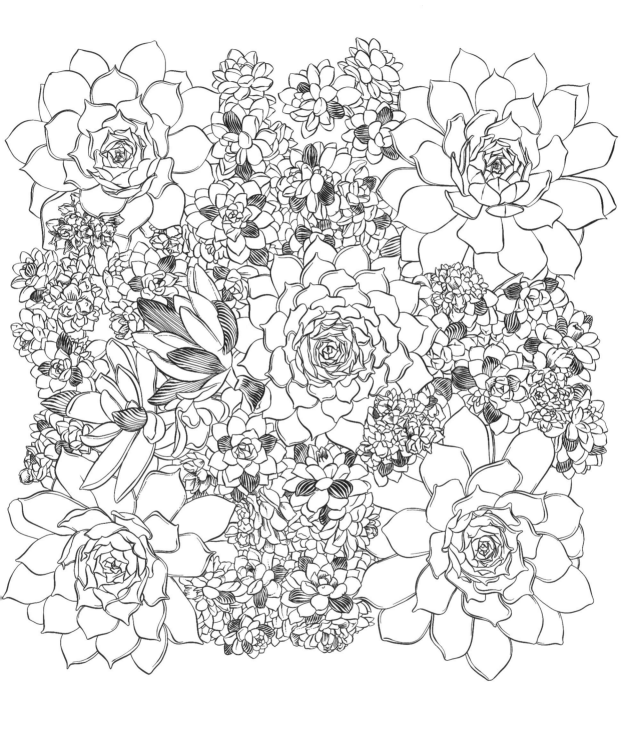

Mandala of echeverias, *Sedum burrito*, and *Agave victoriae-reginae*

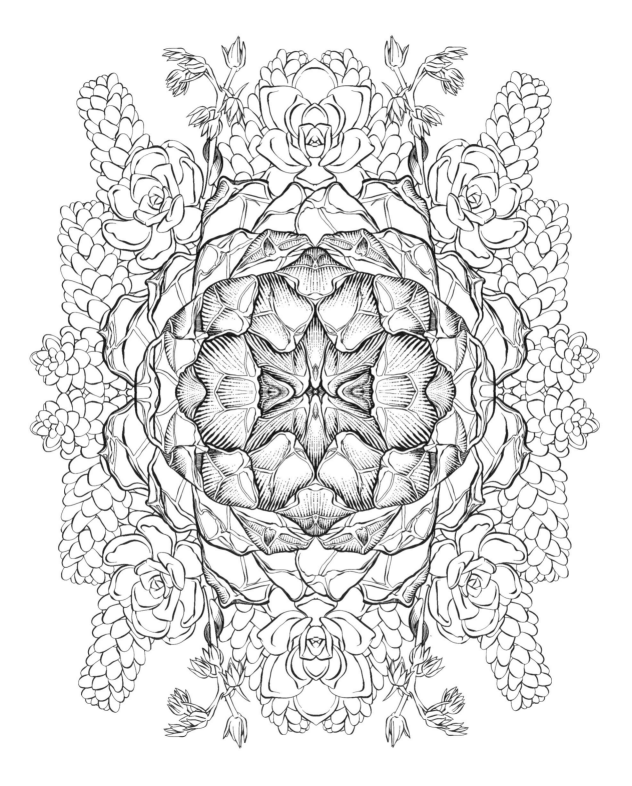

Mandala of sedums and dwarf aloes

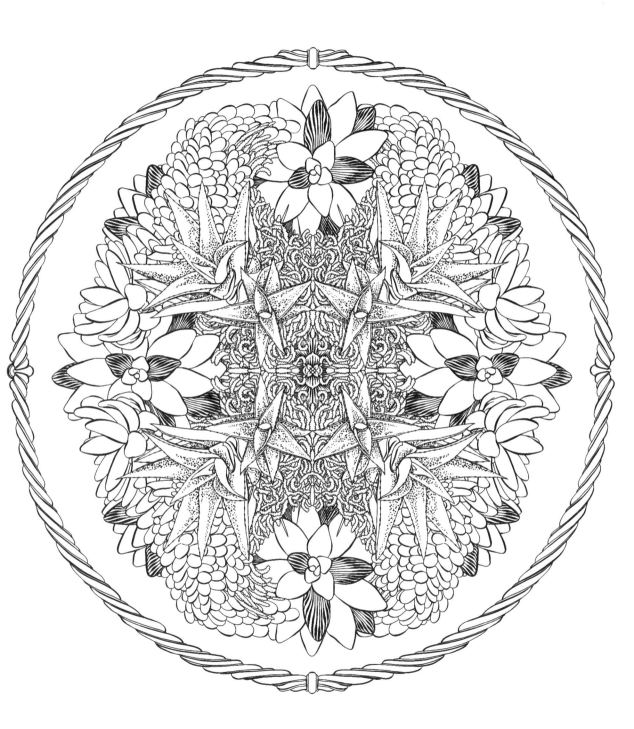

Aloe brevifolia

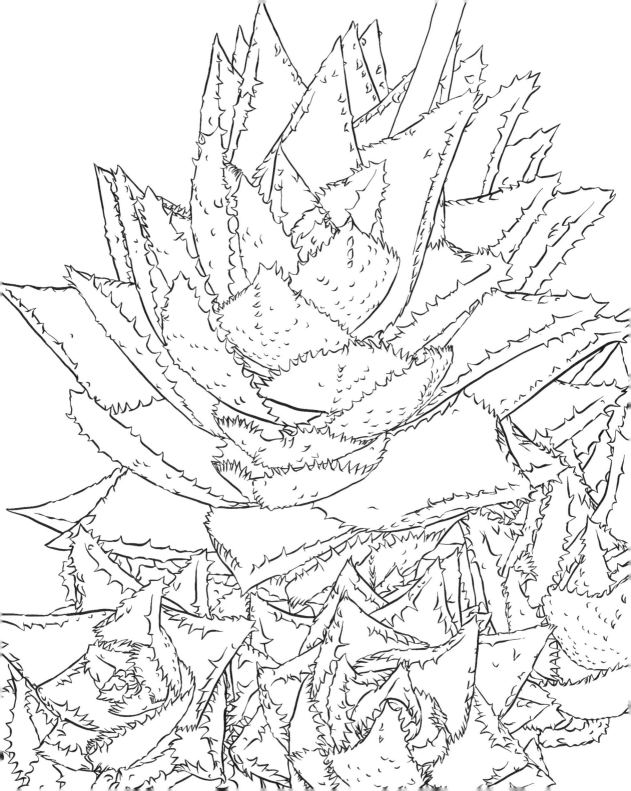

Echeveria hybrid

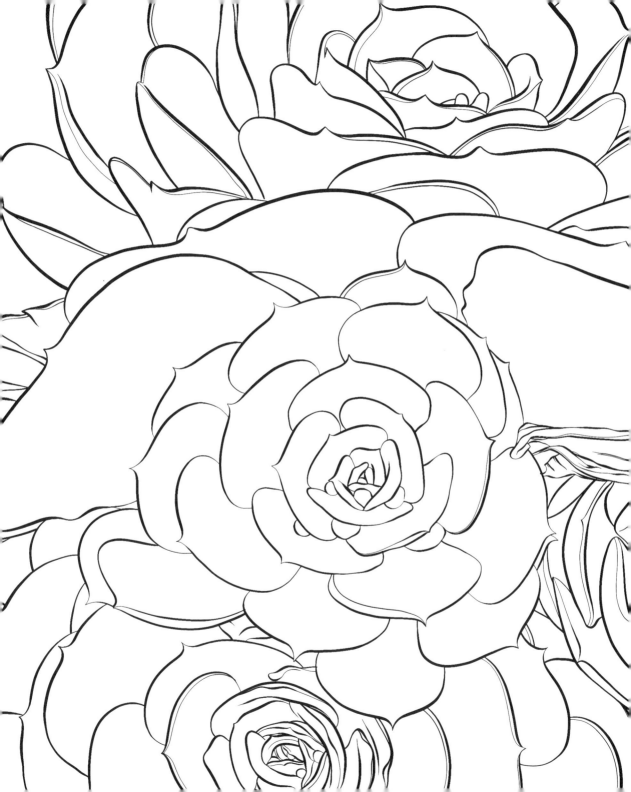

Agave parryi 'Truncata'

Sedum 'Angelina', *Sedum rubrotinctum* 'Pork and Beans', and *Crassula perforata*

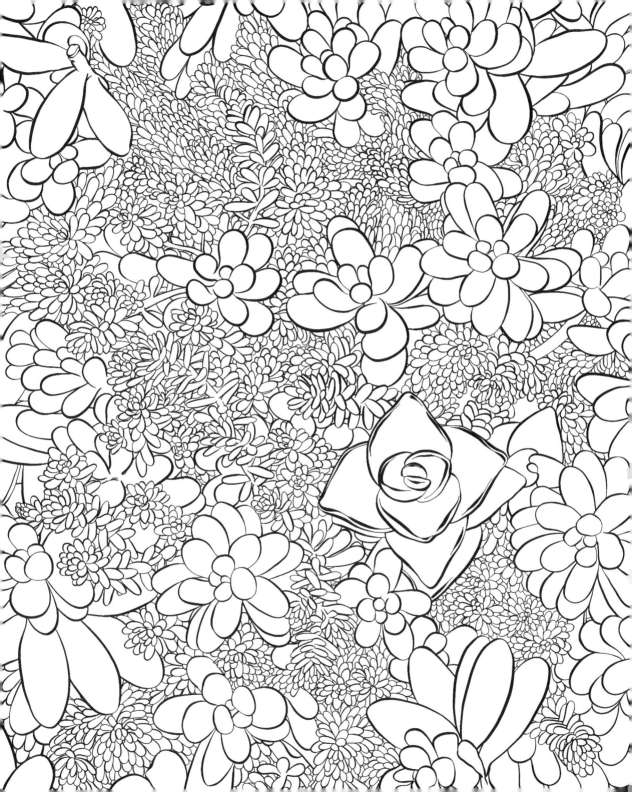

Echeveria cultivars

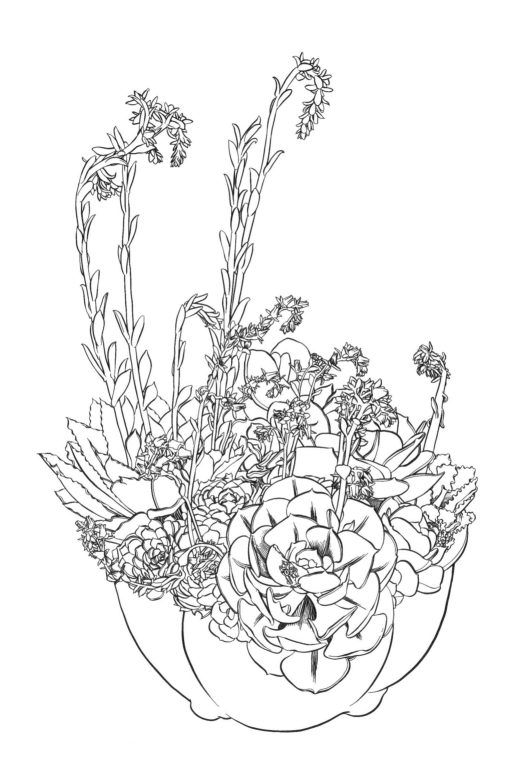

Lithops species

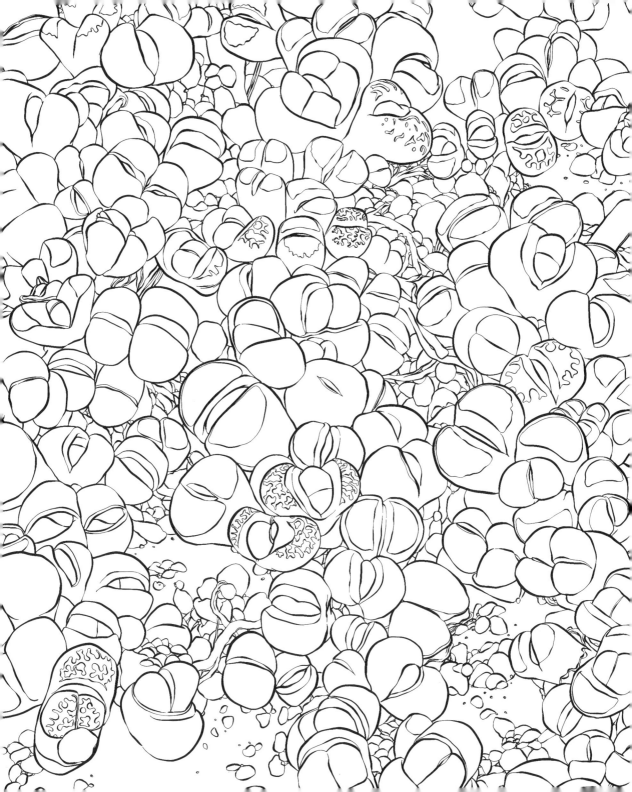

Echeveria 'Neon Breakers'

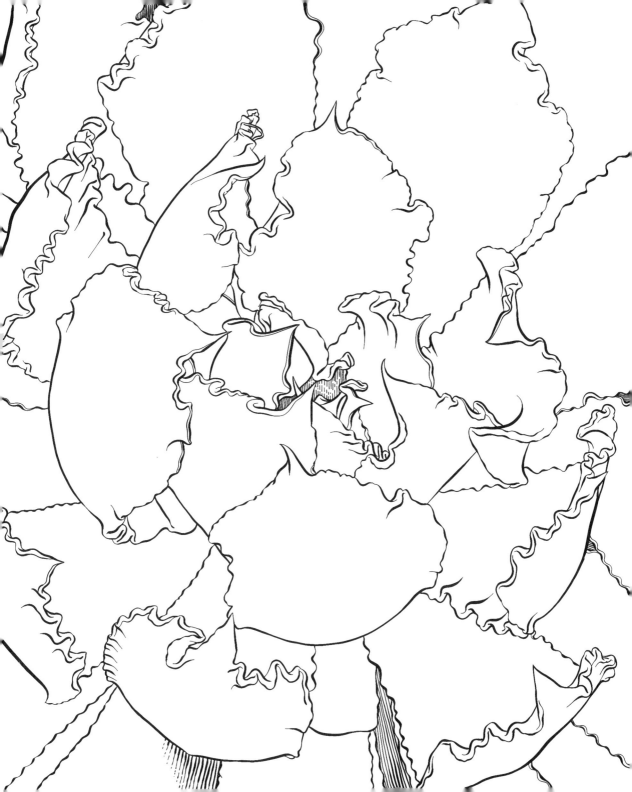

Kalanchoe luciae

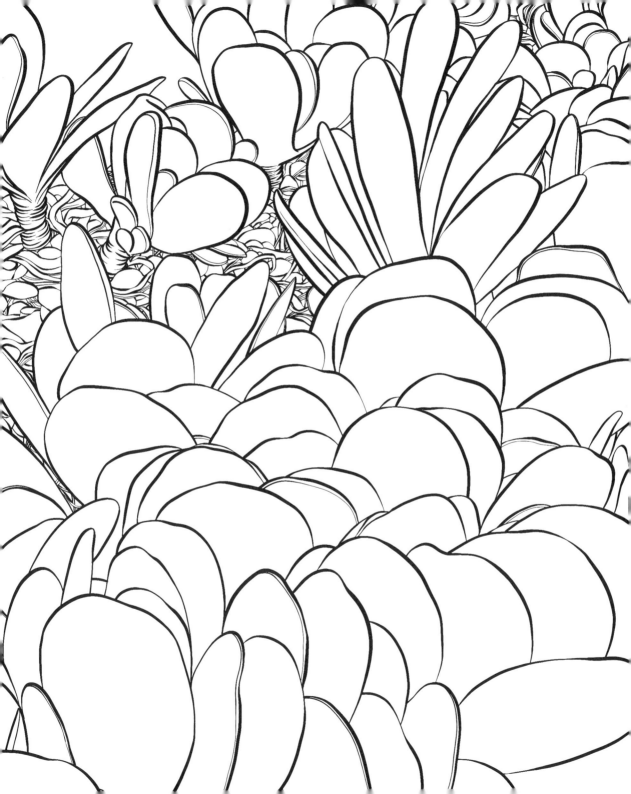

Sempervivum species

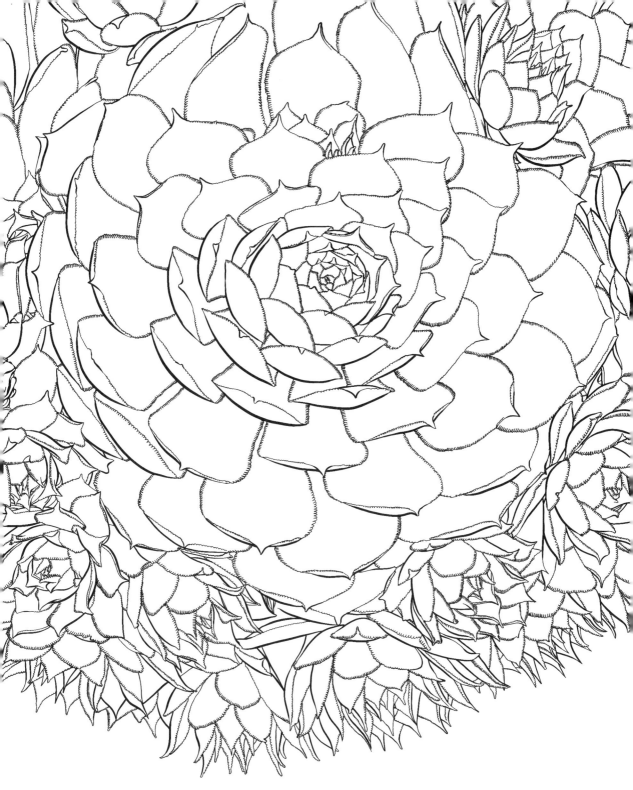

Echeverias and sedums

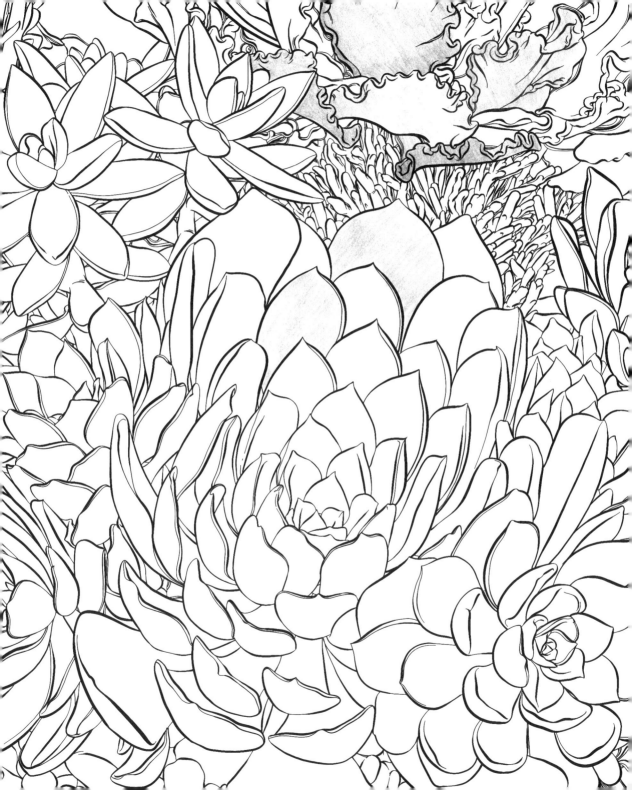

Agave americana 'Marginata', *Crassula tetragona,*
Sansevieria trifasciata, and coppertone stonecrop

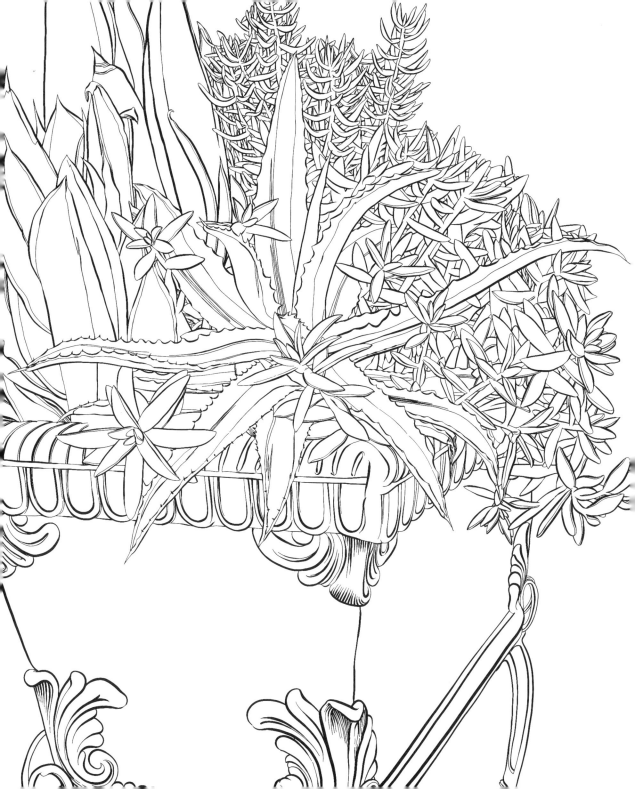

Agave 'Cream Spike'

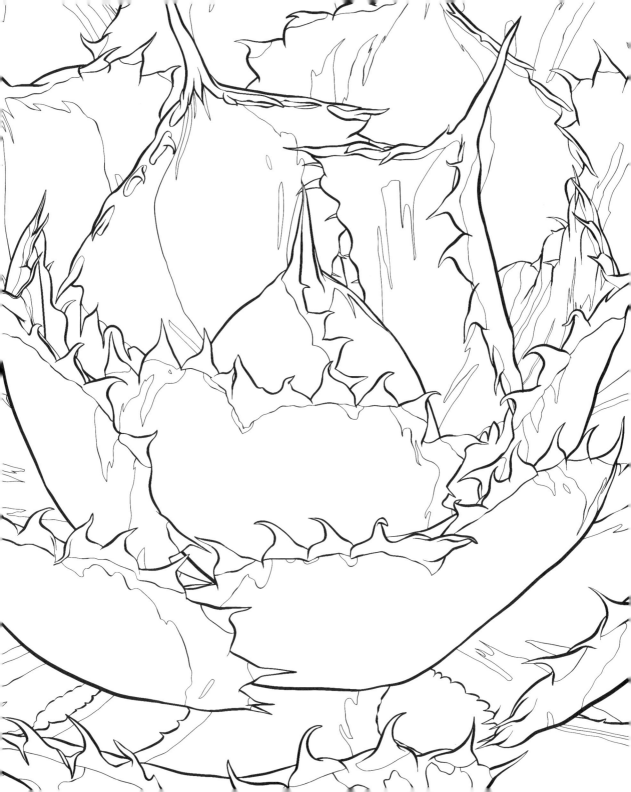

Echeverias and sempervivums

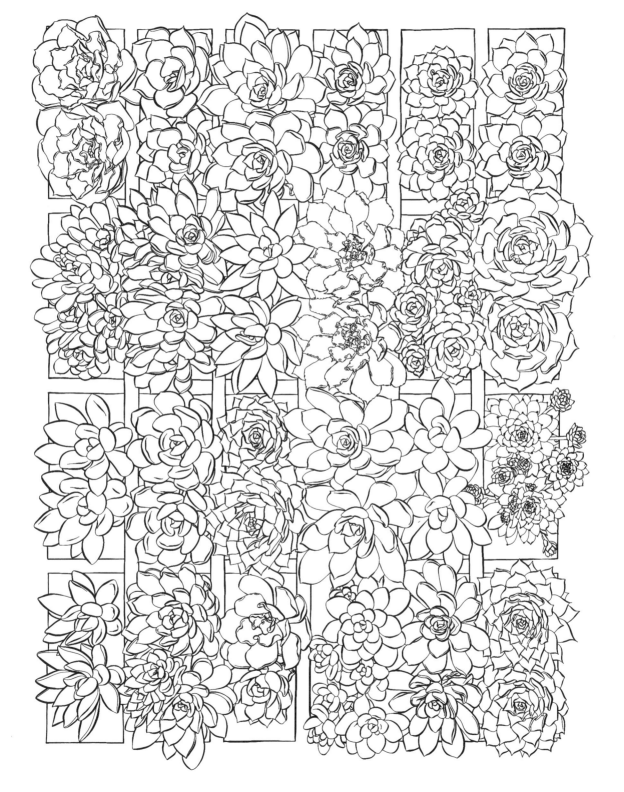

Cactus, dwarf aloes, crassula, and sempervivums

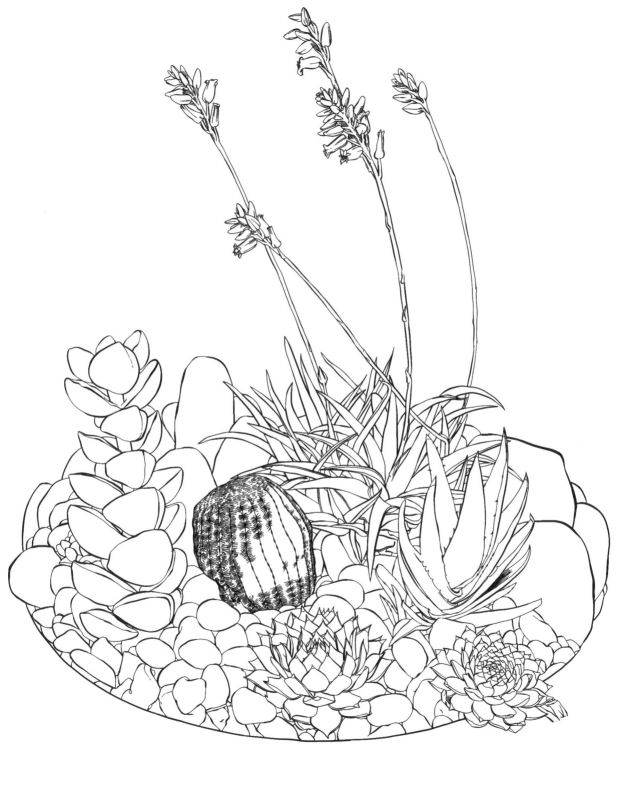

Echeveria 'Topsy Turvy'

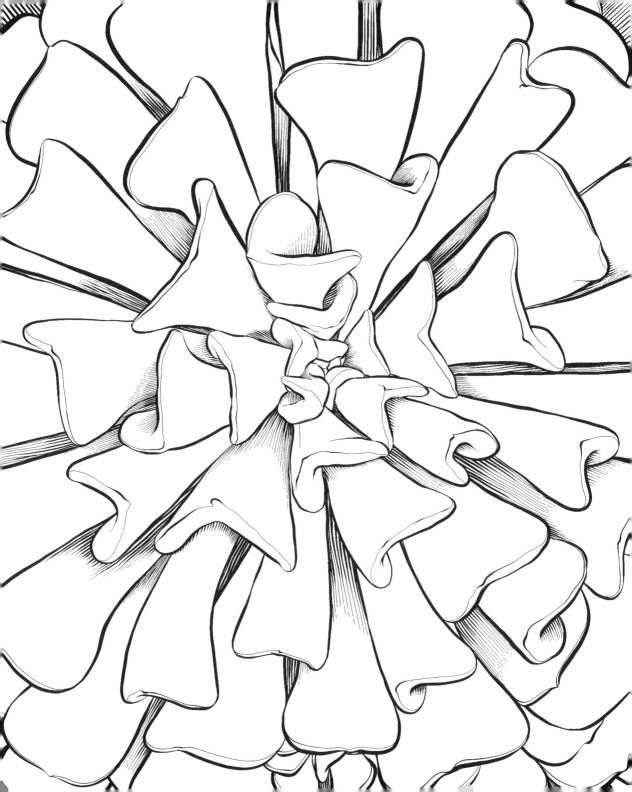

Mandala of echeverias, sedums, and *Euphorbia tirucalli*
'Sticks on Fire'

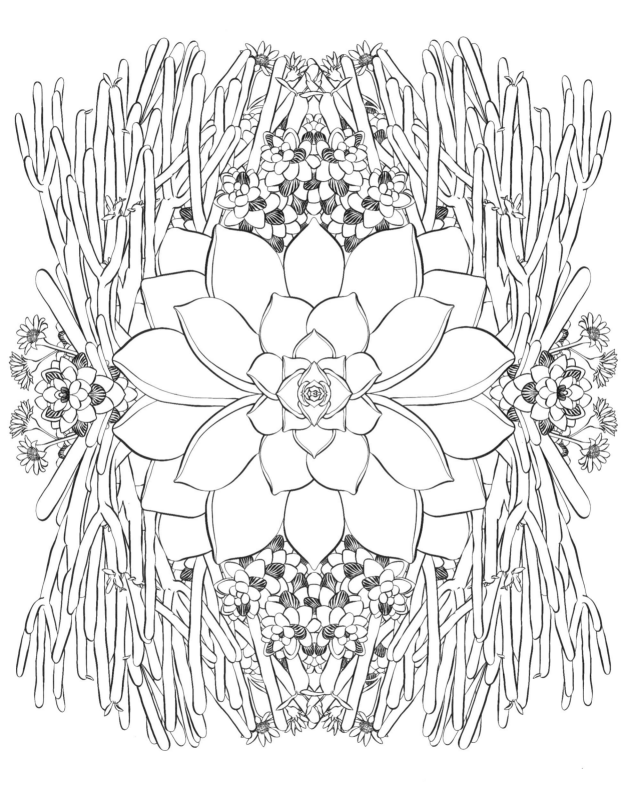

Aloe vaombe

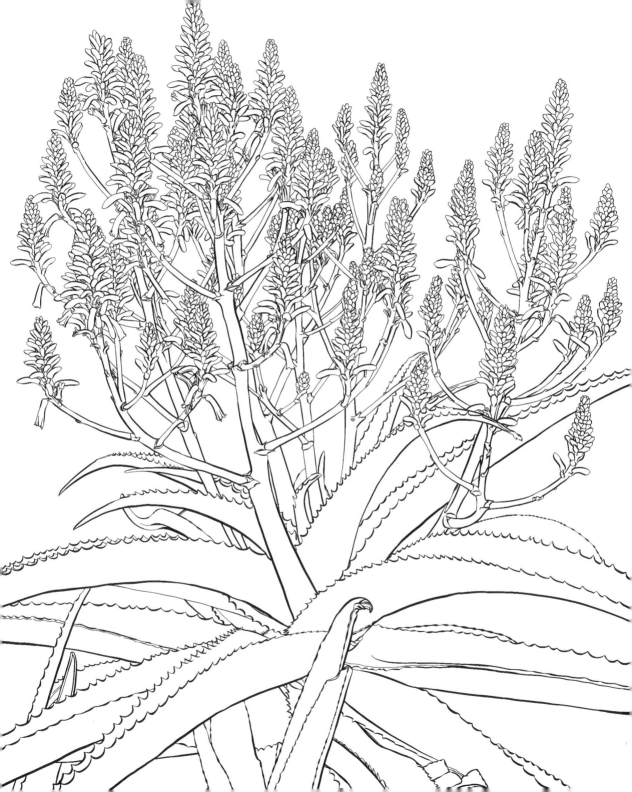

Mandala of *Agave lophantha* 'Quadricolor' and sedums

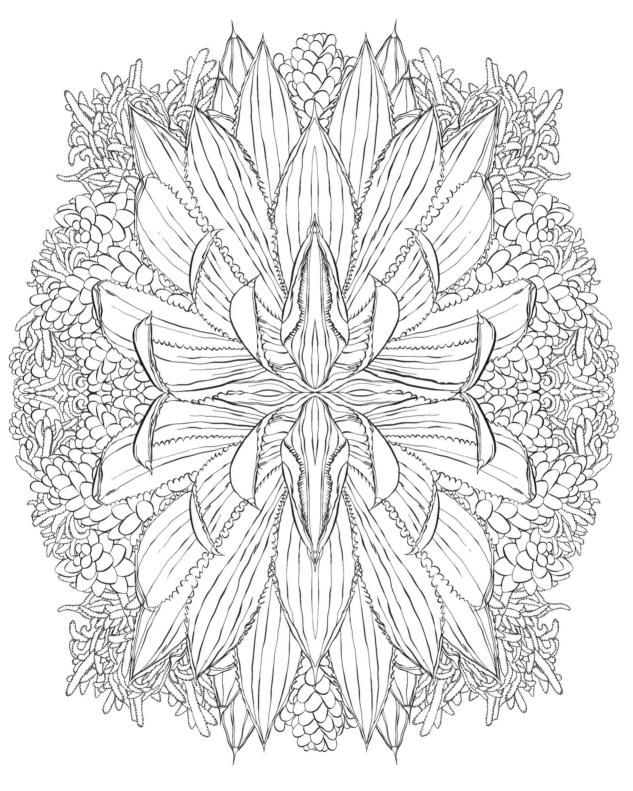

Agave potatorum and *Graptosedum* 'California Sunset'

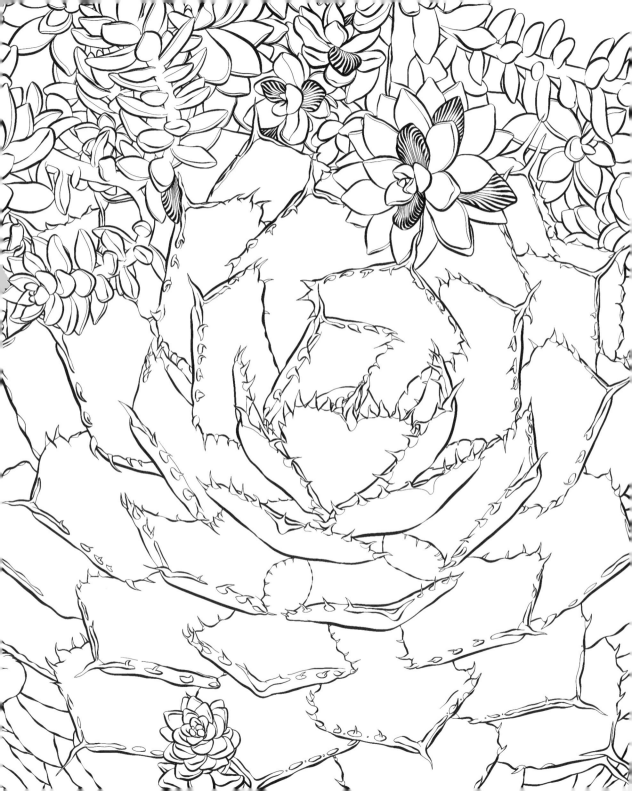

Aloe capitata hybrid

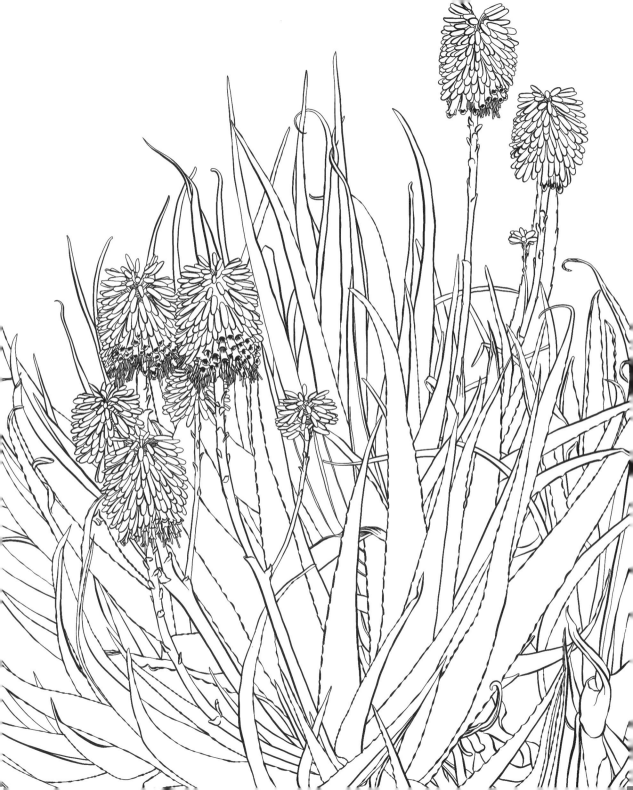

Aloe dorotheae

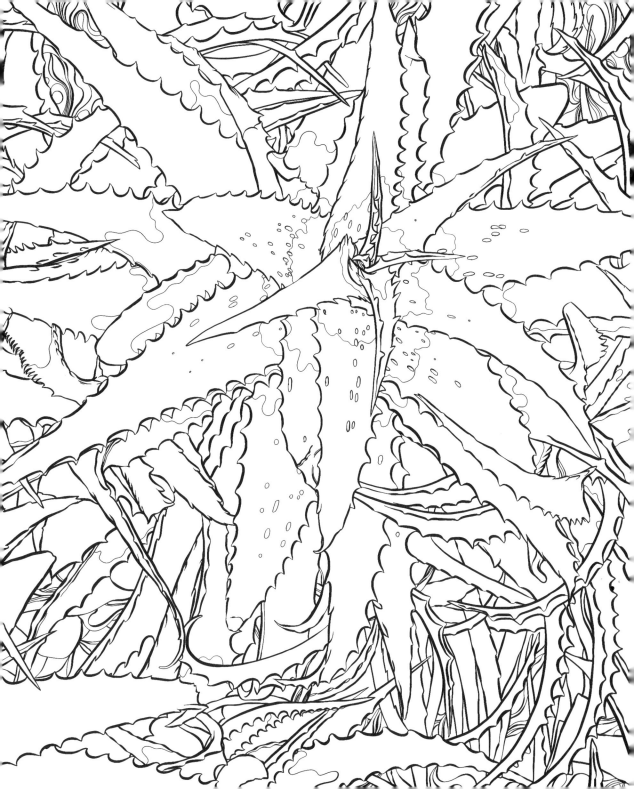

Agave 'Blue Glow' and *Agave parryi* 'Truncata'

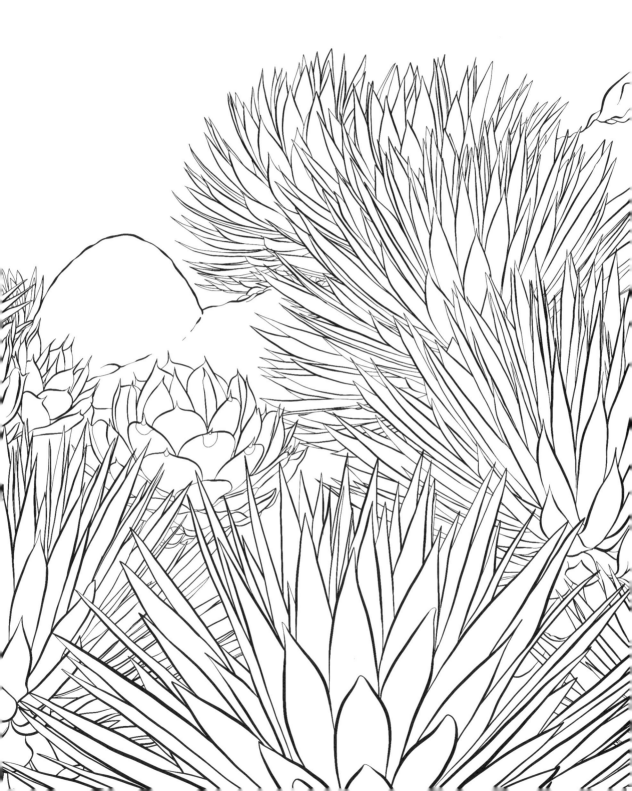

Mandala of crassulas and *Euphorbia tirucalli* 'Sticks on Fire'

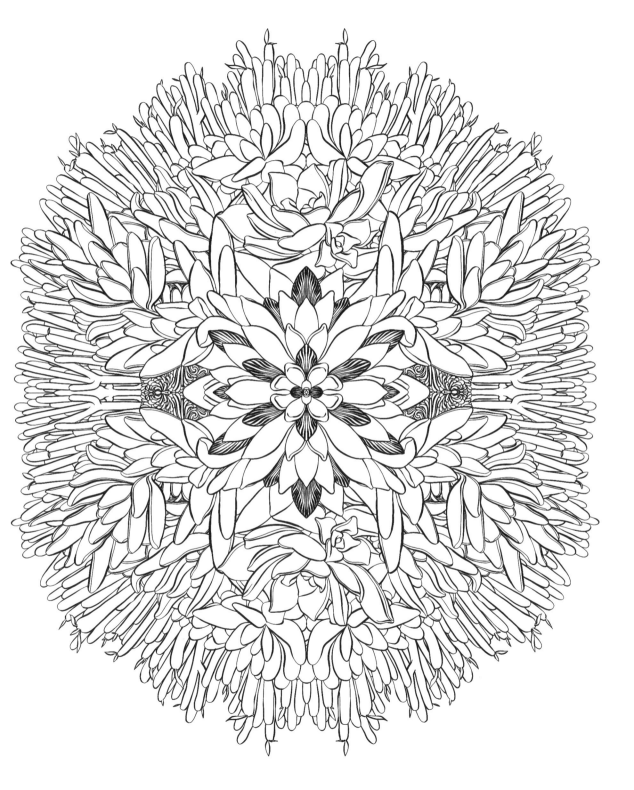

Aeonium 'Sunburst'

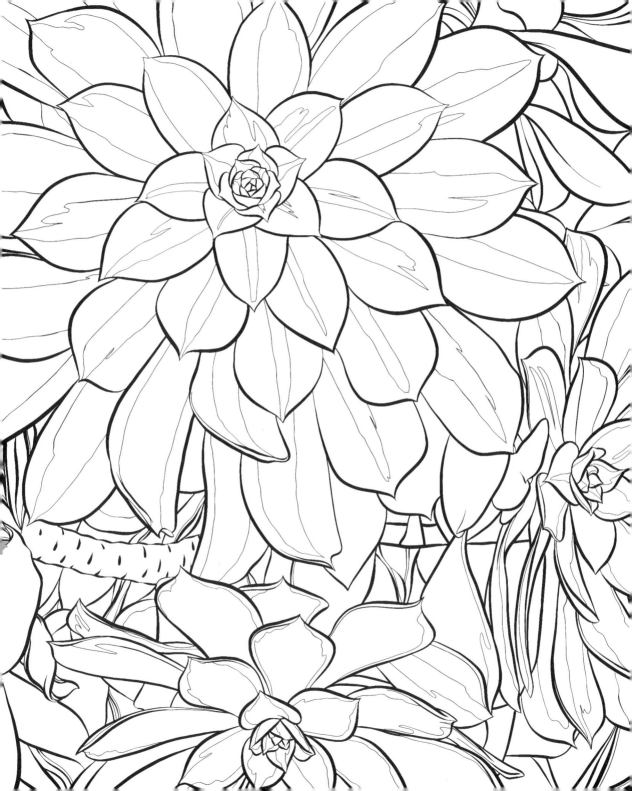

Sedum burrito

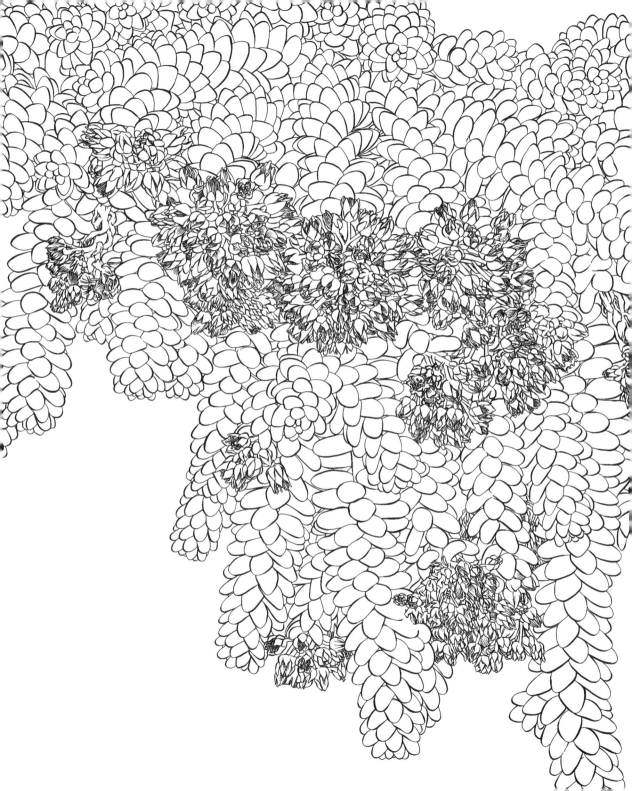

Euphorbia 'Snowflake'

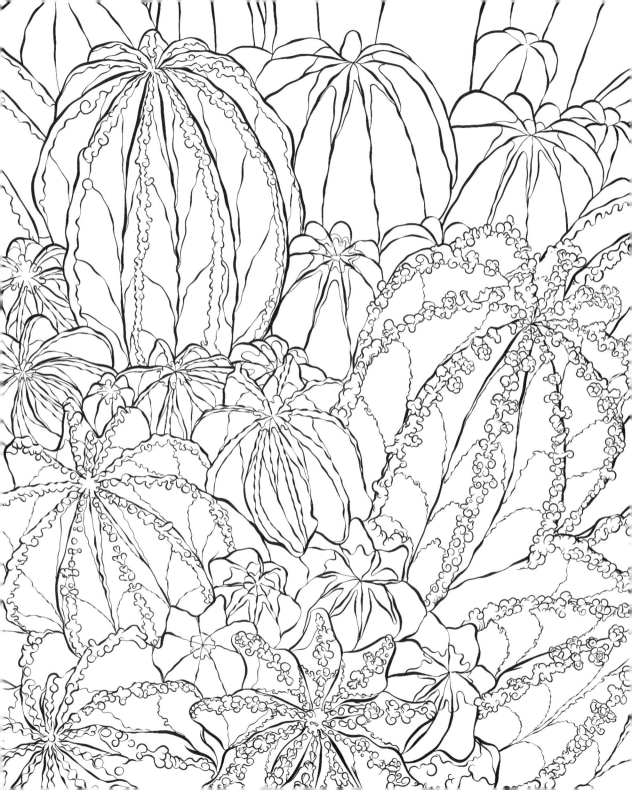

Aloe humilis, Kalanchoe tomentosa 'Chocolate Soldier', and sedum

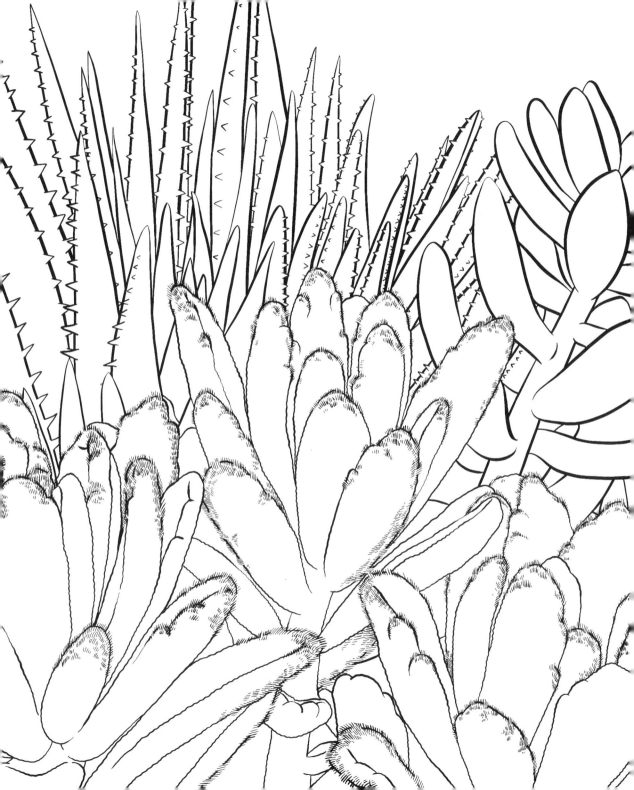

Sempervivum cultivar

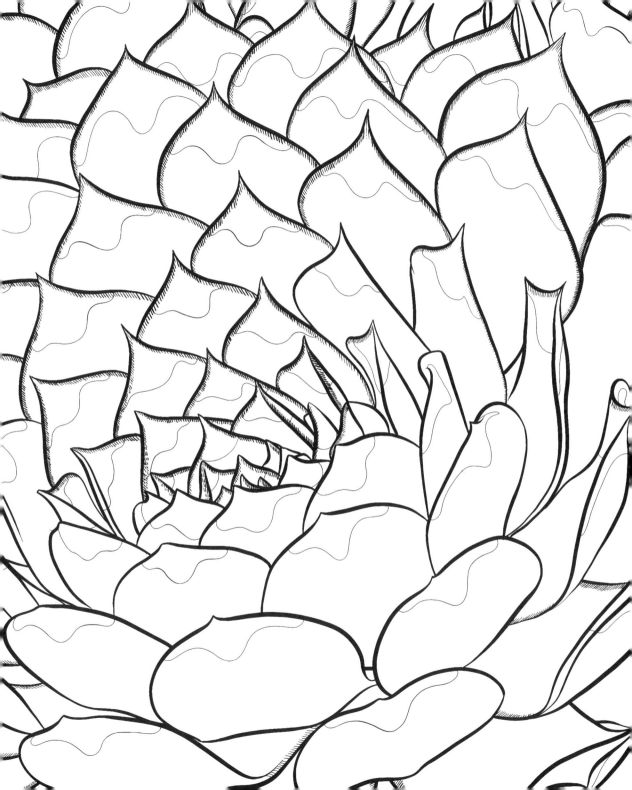

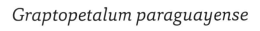

Graptopetalum paraguayense

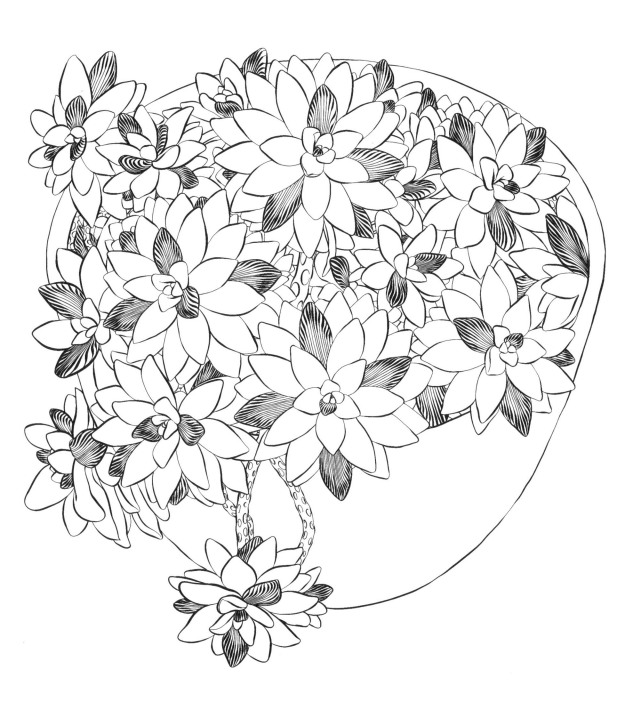

Aeonium 'Party Platter'

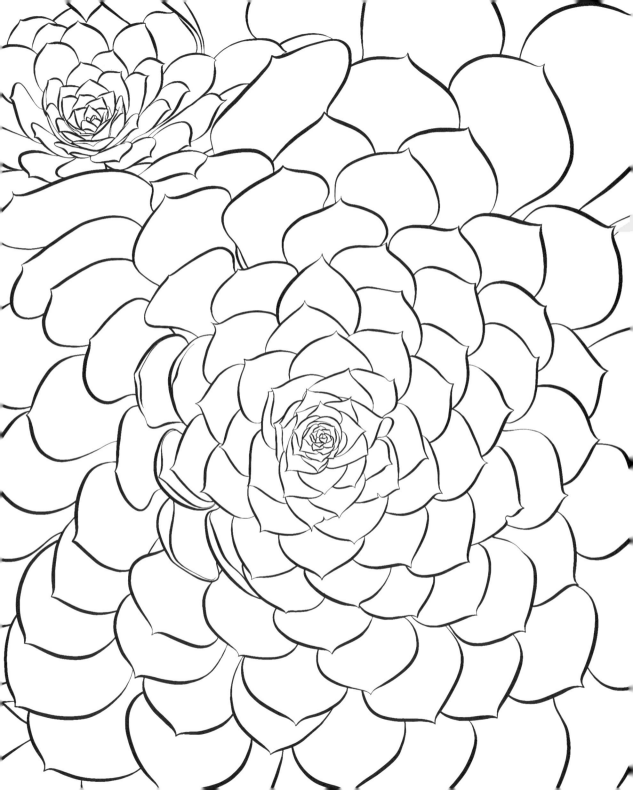

Cactus pot

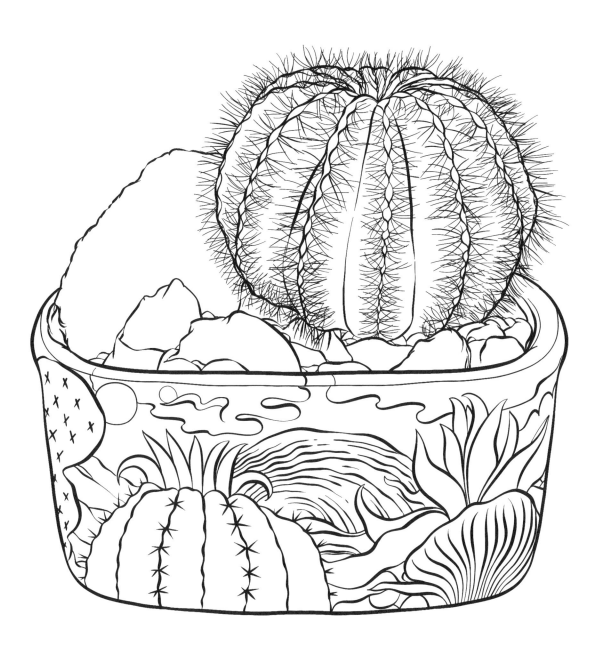

Graptopetalum paraguayense

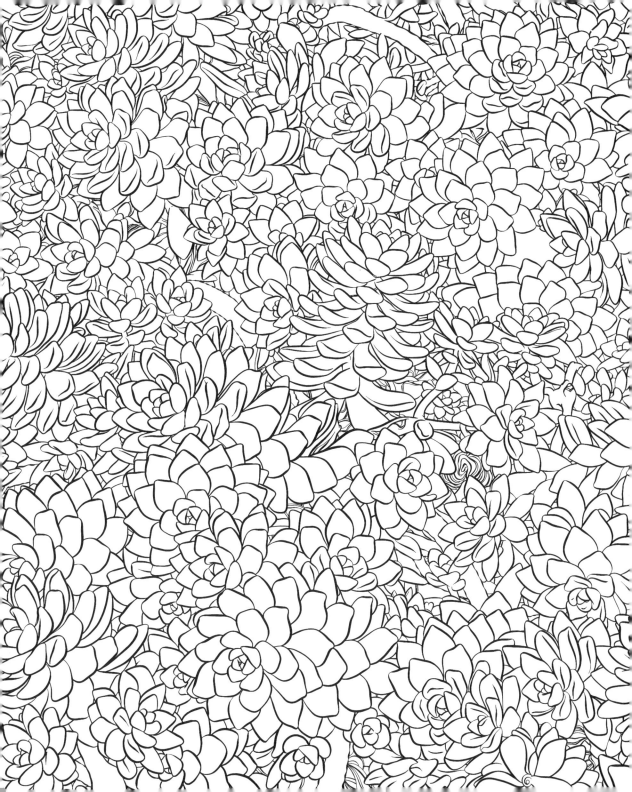

Gasteraloe 'Green Ice', *Echeveria* hybrid, *Sedum dasyphyllum*, string of pearls (*Senecio rowleyanus*)

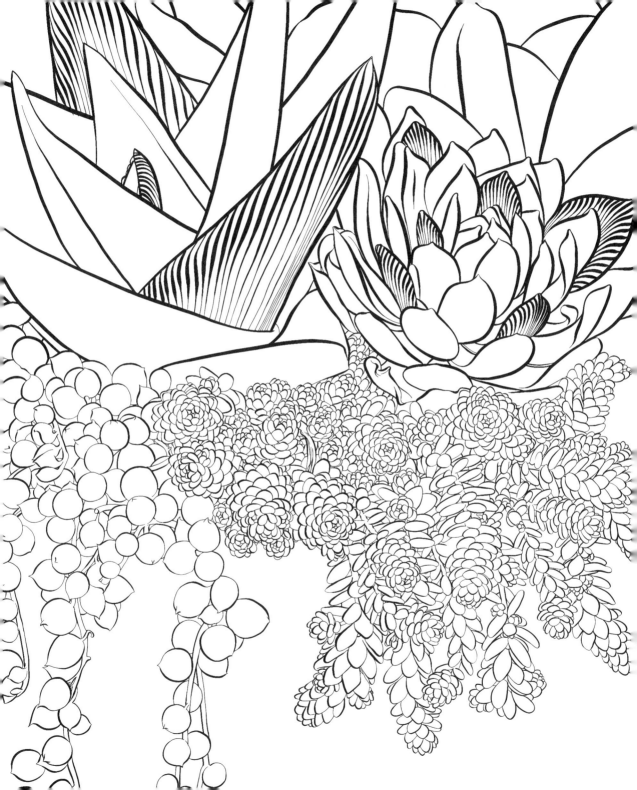

Agave victoriae-reginae

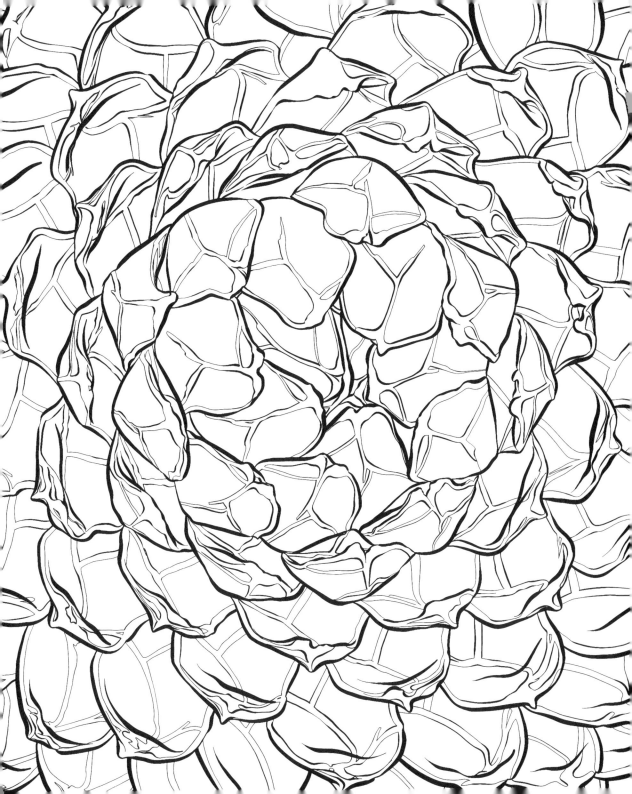

Ferocactus species

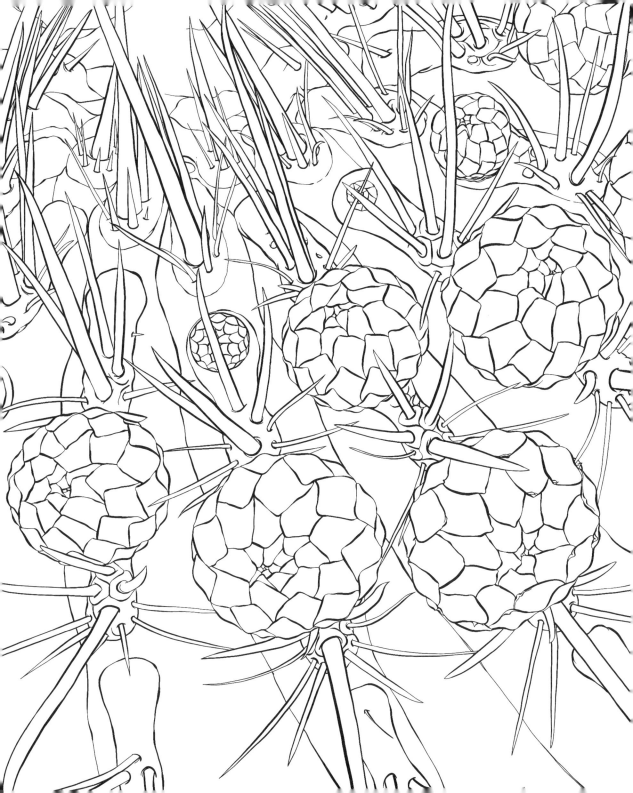

Sedum rubrotinctum 'Pork and Beans' and *Echeveria* 'Lola'
in a Talavera pot

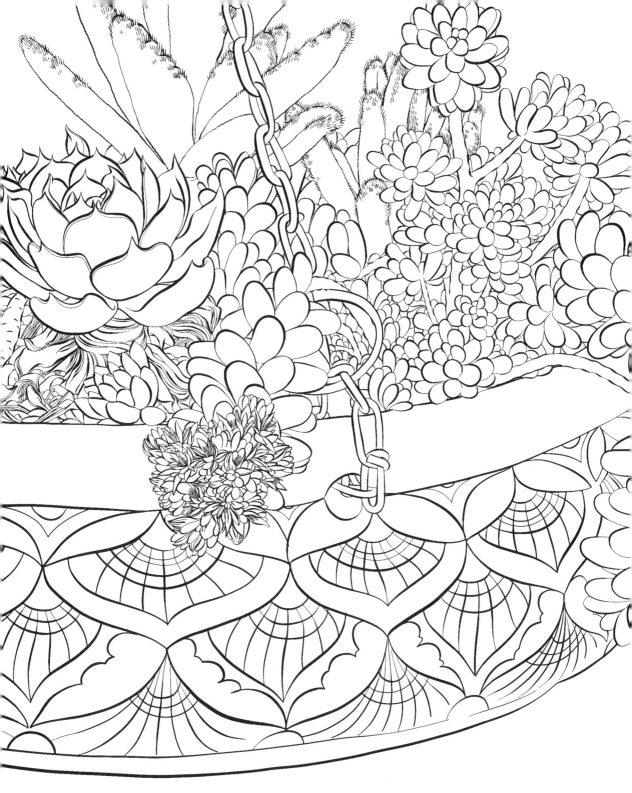

Spiral aloe (*Aloe polyphylla*)

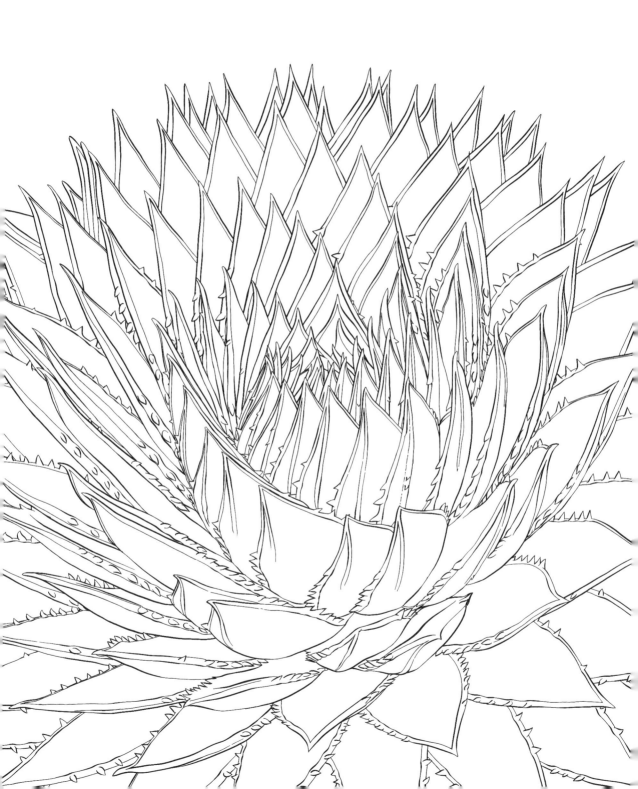

Variegated *Agave americana*

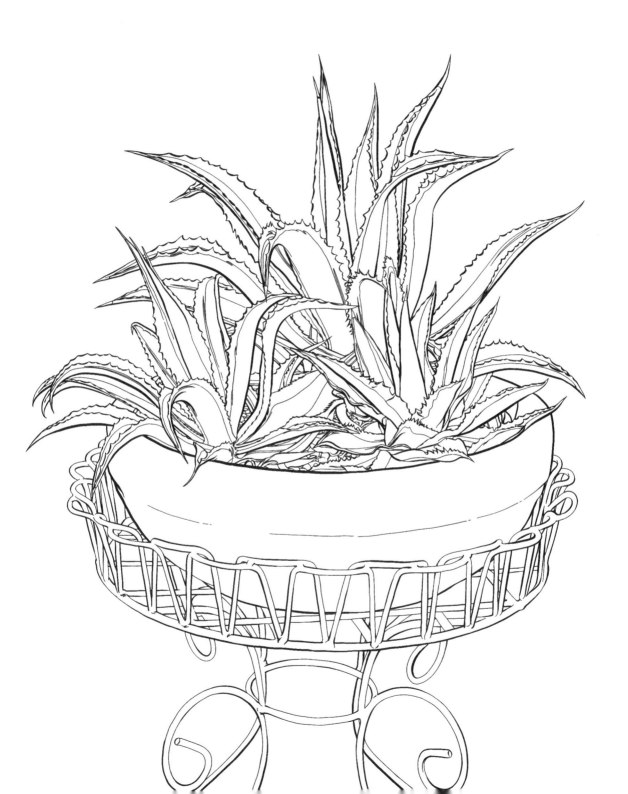

Agave lophantha 'Quadricolor'

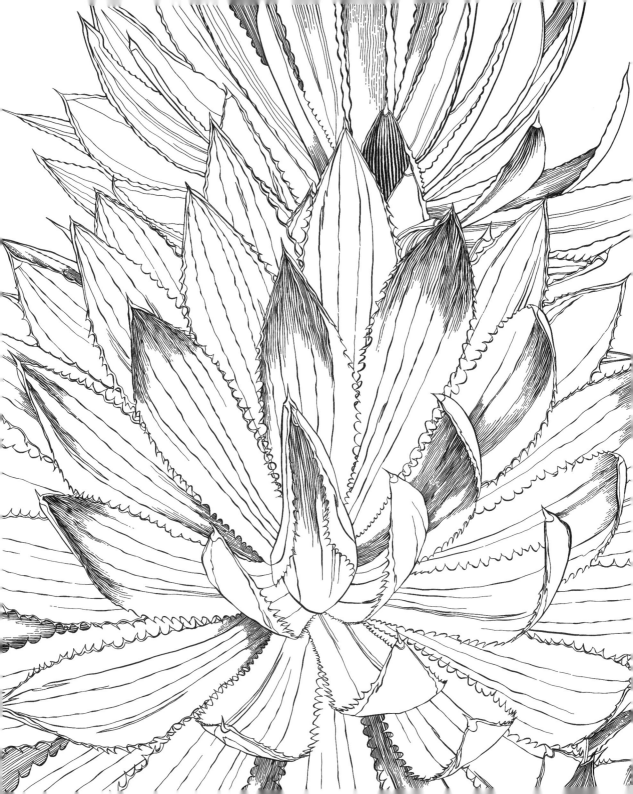

Crassula capitella

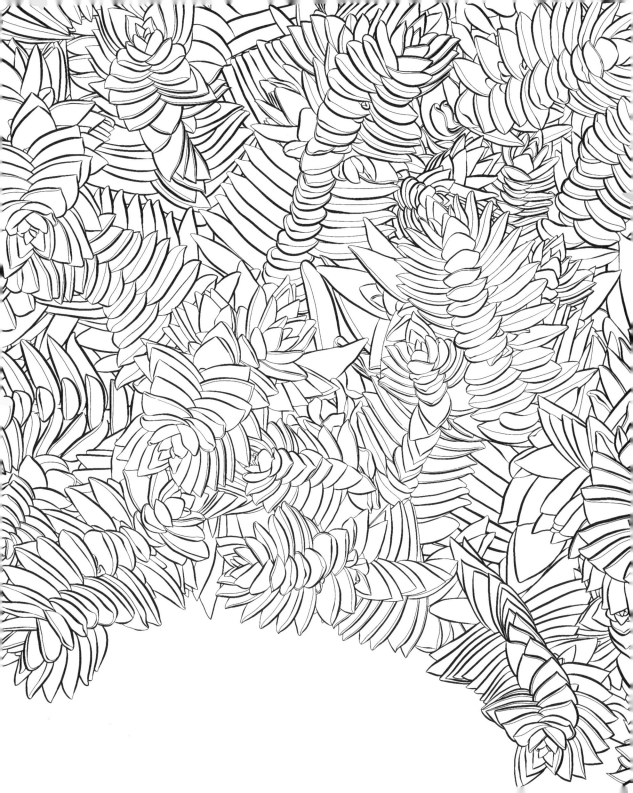

Echeverias, aeoniums, graptopetalums, crassulas, and
cryptanthus bromeliads

ED GOHLICH

LAURA SERRA

Debra Lee Baldwin—also known as the Queen of Succulents—wrote the Timber Press bestsellers *Designing with Succulents, Succulent Container Gardens,* and *Succulents Simplified.* Debra shares the exquisite aesthetics of succulents in everything she does, including her books, photos, videos, newsletters, presentations, and watercolor paintings. Learn more at debraleebaldwin.com.

The child of Sardinian immigrants, **Laura Serra** was raised in a small German town at the border of France. She began drawing at the age of two and never stopped. Her work has always been influenced by two seemingly unrelated subjects: typography and portraiture. With pencil, paint, ink, thread, pixels, markers, and coffee, Laura explores the relationships between characters and curves, letters and faces. See more of her work at lauraserra.org/.

Published in 2016 by Timber Press, Inc.

The Haseltine Building
133 S.W. Second Avenue, Suite 450
Portland, Oregon 97204-3527
timberpress.com

Printed in the United States

Book design and lettering by Patrick Barber

ISBN 13: 978-1-60469-746-9